BEST OF ALASKA
The Art of
JON VAN ZYLE

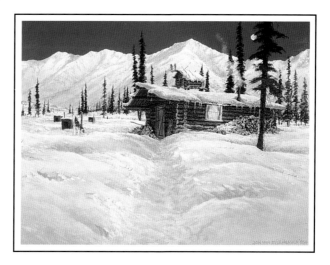

Co-published by

Fairbanks / Seattle

▟▜ Graphic Arts Center Publishing Co.
Portland, Oregon

WILDERNESS ARIA

This painting is perhaps one of my all-time favorites because of the story it tells. I've heard these songs many times and I never fail to marvel at the sensations they give me. To some, it represents a song of the wild ...of the north country. To others, it's ominous and sends shivers down their spines. For me it represents freedom and harmony with nature. Wolves often howl singularly. They use their voices for communication with others in their pack, or perhaps as a territorial call. They seldom bark although I did hear two bark at me when my team and I came upon them one evening. Wilderness Aria...a singular opera of the north country.

20 x 34½ Private Collection

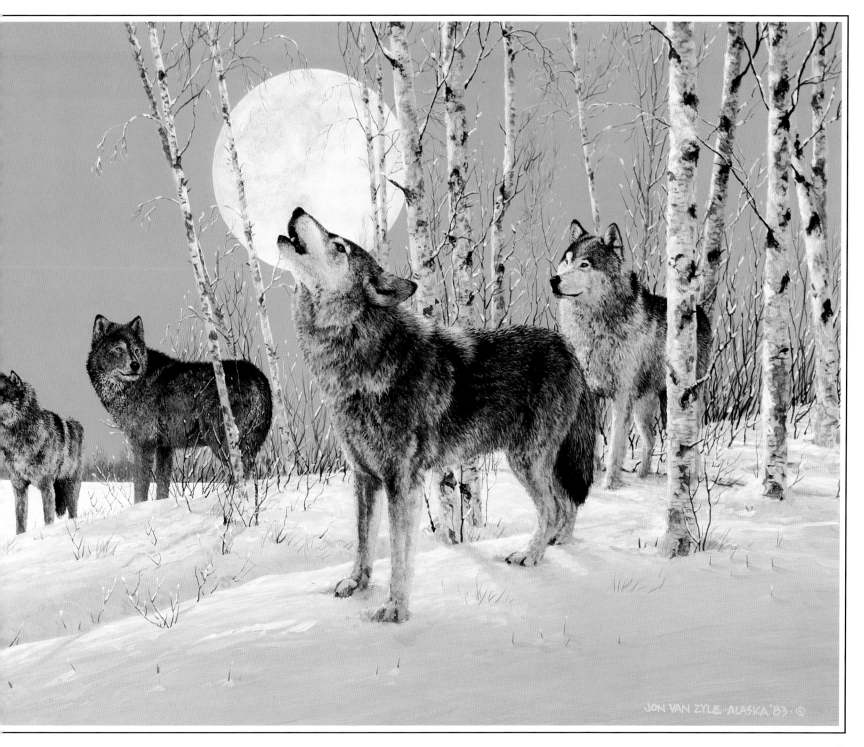

JON VAN ZYLE · ALASKA '83 · ©

TABLE OF CONTENTS

Cover Design: Jon Van Zyle
Inside Design: Jon Van Zyle & Lael Morgan
Typesetting: Technigraphic Systems, Inc.
Production: Martine Richards, Wendy Anderson & Sally Walters
Printer: The Irwin-Hodson Company
Bindery: Lincoln & Allen
Editors: Lael Morgan & Kent Sturgis

Library of Congress Cataloging-in-Publication Data
Van Zyle, Jon.
 Best of Alaska.
 1. Van Zyle, Jon. 2. Alaska in art. I. Title.
ND237.V25A4 1990 759.13 89.1574
ISBN 0-945397-06-2
ISBN 0-945397-07-0 (pbk.)

Epicenter Press Inc.
P.O. Box 60529, Fairbanks, AK 99706 • (907) 474-4969
18821 64th Ave NE, Seattle, WA 98155 • (206) 485-6822
and
Graphic Arts Center Publishing Co.
P.O. Box 10306, Portland, OR 97210 • (503) 226-2402

PRINTED IN THE UNITED STATES OF AMERICA
Second Printing

This book is dedicated to my late mother who gave me the yearning to paint.
And to Char, who provides me the peace to fulfill my dream.

Jon Van Zyle

FOREWORD

The work of Jon Van Zyle is treasured by those of us who have been privileged to travel Alaska's little-known trails in all seasons.

"He paints true, just like it is," an old prospector once told me in astonishment. "Cold snow and warm memories. I didn't think anybody painted such things!"

For those who dream of coming to this wonderfully wild land where mountains and rivers still go unnamed, Van Zyle's brush will whisper exciting promise for, indeed, he does capture the best of Alaska with extraordinary skill.

Lael Morgan

Fairbanks, Alaska

ARTIST'S STATEMENT

I GREW UP IN A FAMILY WHERE ART AND ANIMALS—ESPECIALLY DOGS—WERE ALL IMPORTANT. MY MOTHER, WHO raised dogs for a living, was a wonderful artist, and my twin brother and I inherited her natural talent. She taught us to hunt and fish, to live off the country, and to me she passed on the Alaska dream as well.

All my life I had wanted to come here. The yearning never waned, and when I moved north in 1971, I felt as if I'd finally come home.

Earlier, while working in Hawaii, I'd met and married my first wife, Priscilla. A native of Filipino, Hawaiian and Chinese ancestry, she kindled my interest in indiginous beliefs and traditions, and I was equally fascinated with peoples of the far north.

I already was acquiring Siberian Huskies, and soon the dogs became not only a focus in life, but in my art as well. When the fledgling Iditarod Race was organized in 1973, I helped my friend, Darrell Reynolds, prepare for the trail from Anchorage to Nome—vowing to run it myself some day.

I began painting in earnest. As a child, I drew and painted constantly. In college I experimented with every medium, from oils to sculpture, from abstract to realism. As an artist in Hawaii, I tried a tube of acrylic paint and found a medium I loved. Now, in Alaska at last, I found my subject.

My first Iditarod was a wonderful experience. Traveling along the trail was like going back in history. The route is a cross-section of Alaska: rugged mountains, endless tundra, biting winds and overflow water on wide, frozen river "highways." The 1,100-plus miles were at once beautiful and dreadful, boring and stimulating . . . I found out who I was, and what was important to me. After that long journey, I painted a series of twenty scenes based on the adventure.

When I paint I see a picture in my mind that evokes an emotion. It is the emotion I am trying to convey, not just the image. A powerful experience like the Iditarod . . . something intensely personal . . . works best.

The first Iditarod poster came out of that series of paintings. It was intended to be a one-time effort to promote the race, but led to an annual sequence that has become a large part of my career.

Jon and Charlotte Van Zyle
Rob Stapleton photo

In 1979 I ran the Iditarod again, ended my first marriage and met my future wife, Charlotte. With her, she brought an "instant family." Her two teenage children and her parents were a joy and, with them, missing pieces fell into place.

Char became my right hand; our interests and goals became one. With her guidance, I learned to enjoy and understand people, adding a wonderful new dimension to my life . . . and to my art.

I love Alaska. I love what it stands for and what we have made for ourselves here. Through my painting, I want to share this love. I want others to experience an Alaska sunset, the brilliant cold of a winter's night . . . and feel the warmth from a dog's fur.

STUDY OF A PERFECT HAIRLINE, pastel sketch

8

JON VAN ZYLE'S LEGACY

By Carol A. Phillips

The lonely tundra domain of gray wolves, mountain passes drifted with snow, isolated wilderness rivers and the fabled trails of the pioneers—all are as remote as their legends to most of us. They are made real through the paintings of Jon Van Zyle. His eloquently communicated vision carries the weight of years devoted to fulfillment of an Alaska dream, and his long experience in its lonely wilderness stamps his work with authenticity.

"I want to paint only what I know," Van Zyle maintains. What he knows is Alaska, in all its infinite and overwhelming variety: the abundant wildlife, the pervasive solitude of towering mountains and the faces of its strong, independent people. It is knowledge hard won, much of it absorbed through mushing hundreds of hours over frozen trails behind a team of sled dogs.

Only one who has been there could capture so dramatically the danger, frustration and mystical beauty of the event known as the Iditarod, an annual sled dog race that traverses more than 1,100 miles over some of the most forbidding terrain in North America.

Why would anyone willingly subject himself to such an ordeal? Is it the challenge of competition? The hope of the prize? A gambling instinct? Is it fellowship with one's dogs, an appreciation of endless vistas, the lure of the unknown, a chance to triumph over vicious storms and ever-present danger?

Jon Van Zyle nods and smiles at the theories. It's all of this...and so much more.

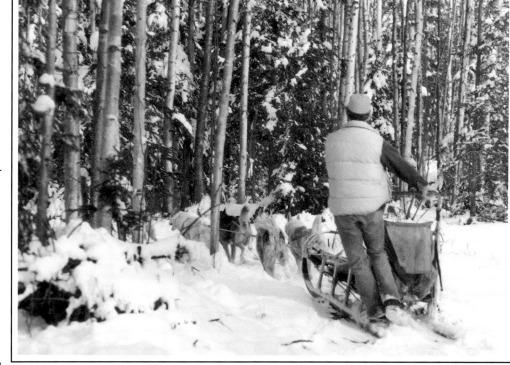

Jon Van Zyle on the mushing trail.
Charlotte Van Zyle photo

9

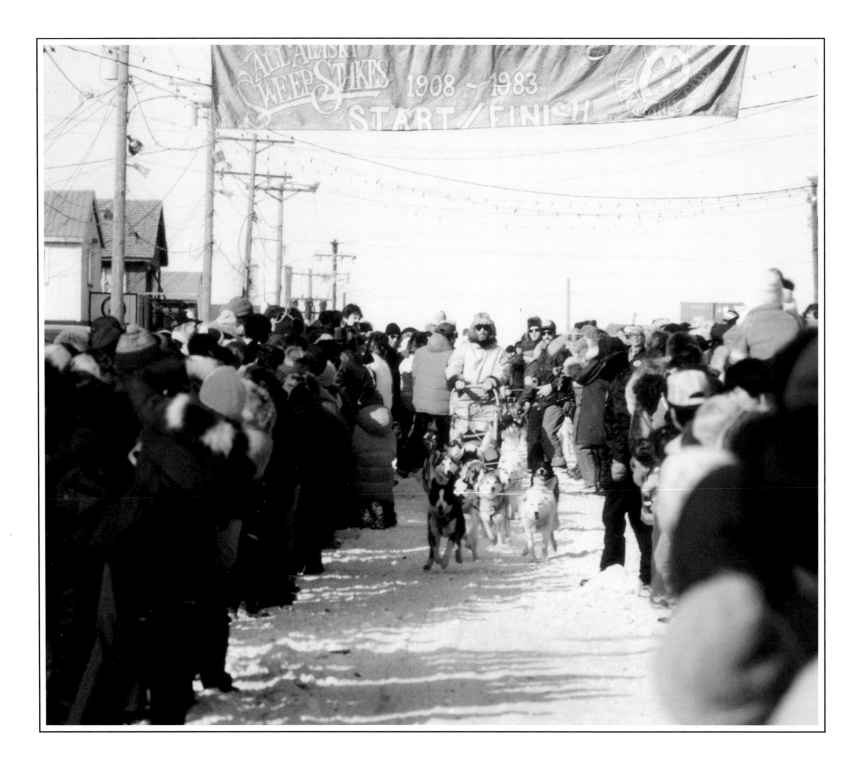

His voice is hushed as he tells of encounters with wolves on the trail, the nervous reactions of his dogs, the calls of wild animals across the tundra and around his dog yard. He relives the pleasures of training and camping with his team in the Denali country of interior Alaska. He tells a story about a dark night on the Post River during the 1979 Iditarod race. His headlamp is malfunctioning; there is danger on all sides from overflow and stretches of open water. Unable to see, he slowly leads his dogs across hazardous ice. Earlier, a friend had counseled him to call upon the "white light" for protection on the trail. In this time of need, he remembers these words and evokes the "white light." Later, after Van Zyle and his team made it through the dangerous stretch, another musher told them he had witnessed their plight from behind.

"But it was pitch dark," Van Zyle protested. "My lamp wasn't working."

"Maybe so," replied the other musher, "but I saw you. There was a light all around you."

Where words so often fail, Van Zyle's brush expresses all. Here are the rare, unforeseeable moments, visions rooted in stress, fatigue, excitement —or something else, some trick of the imagination, some deeper perception, when the land itself speaks and the faces of those who have gone before join a musher on the trail, ghostly companions through the terrible beauty of the Alaska winter.

The life Van Zyle knows today has its origins in a rich heritage passed on to him by his mother, Ruth, a courageous woman who raised her identical twin sons alone under difficult circumstances. From the time of their birth in Petoskey, Michigan, in 1942, through moves to New Jersey, then to a rural area of central New York State, Jon and his brother Dan

Jon Van Zyle leaving the starting line in Nome's All-Alaska Sweepstakes in 1983. After years of regular mushing competition, the artist now has a smaller team and no longer competes. Jeff Schultz photo

were influenced by their mother's compelling creative energy. A skilled artist, self-taught and unrecognized, she encouraged her sons' talents.

A strict but loving upbringing showed the boys the value of hard work. Both labored like adults from the age of 12, holding down every conceivable after-school job. In addition, they also helped run a kennel of working collies which provided some of the family's livelihood. For some years the idea of becoming veterinarians appealed to the twins.

Then there was the dream. Ruth Van Zyle dreamed of Alaska. Images of northern lands filled her hopes and plans. When the family moved to Colorado in the early 1950s, it seemed a giant step in the right direction. Ruth no doubt would have opted for Alaska but a friend, a surrogate grandmother to the twins and a strong influence on the family, preferred to settle in Colorado.

The Van Zyle boys grew up in Boulder, then Lakewood, where Jon recalls school days were often rocky but remembers fondly outdoor activities, athletic events and family functions. Ruth worked at a variety of jobs. There was less kennel work now, for she had lost her East Coast clientele, but there were always dogs. And she continued to encourage her sons' artistic endeavors.

As high school seniors, Jon and his brother enlisted in the National Guard and took their basic training at Ford Ord, California, following graduation. Then for the next year and a half they attended Mesa Junior College in Grand Junction, studying art and getting to know Colorado by establishing a small guide business. Van Zyle remembers college as fun, due mainly to his girlfriend. Jon Van Zyle particularly remembers 1963, the year he acquired his first husky dog.

Ruth had a good job at that time, but when she suffered a massive stroke in the early 1960s, all their lives changed. Her illness required lengthy rehabilitation. The twins supported her while she learned to walk and talk again. When she had recovered

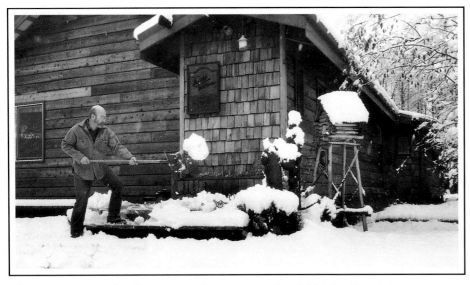

Shoveling out the homestead at the end of Mink Creek Drive near Anchorage is no small job after a winter storm. Charlotte Van Zyle photo

sufficiently for them to leave her in the care of their devoted "Granny," the young men accepted construction jobs in Hawaii, where they filled after-work hours with diving, a fish business and, of course, painting. Jon bought his first tubes of acrylic, and this soon became his favorite medium.

Dan found a happy home in Hawaii, where he lives and paints today, but Jon was still restless. In Honolulu, he hired on as a display man for Sears and Roebuck, was moved by the company to Portland, Oregon, promoted to an executive position in Los Angeles, and made twenty-seven moves during a four-year period during which he designed new store interiors and remodeled old ones.

Residence in Oregon gave Van Zyle a chance to put together his first dog team and he enjoyed mushing so much that he began to think once again of moving to Alaska. His company made a job for him in their Anchorage branch in 1971 and Van Zyle soon became known in mushing circles, racing and adding steadily to his small team of Siberian Huskies. In 1973, he assisted a friend who was entering the Iditarod and two years later he told Sears and Roebuck he wanted to run the race too. His manager seemed agreeable but would not give him the necessary time off, so, determined to compete in 1976, he said good-bye to the company

and began serious training for mushing's most famous competition.

Van Zyle's painting career took off at the same time he got into mushing. It seemed natural to him to combine sled dog racing with his passion for art and he later became affiliated with Artique, an Anchorage art gallery. Happily he retired from corporate life to the scenic Eagle River Valley, just outside of Anchorage, where he built up his kennel, trained his teams, and painted. After running the 1976 Iditarod, Van Zyle produced a series of twenty scenes from experiences on the trail. In 1977, he published his first Iditarod poster, a collector's treasure today. Although he ran the race for the last time in 1979, he still holds his title as official Iditarod artist.

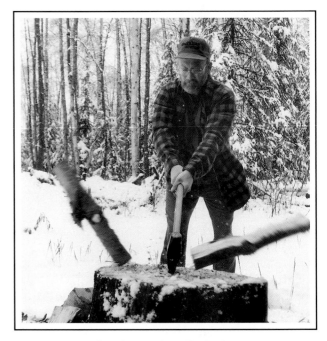

Jon Van Zyle chops kindling for a wood stove in the family home on Mink Creek Drive. Charlotte Van Zyle photo

12

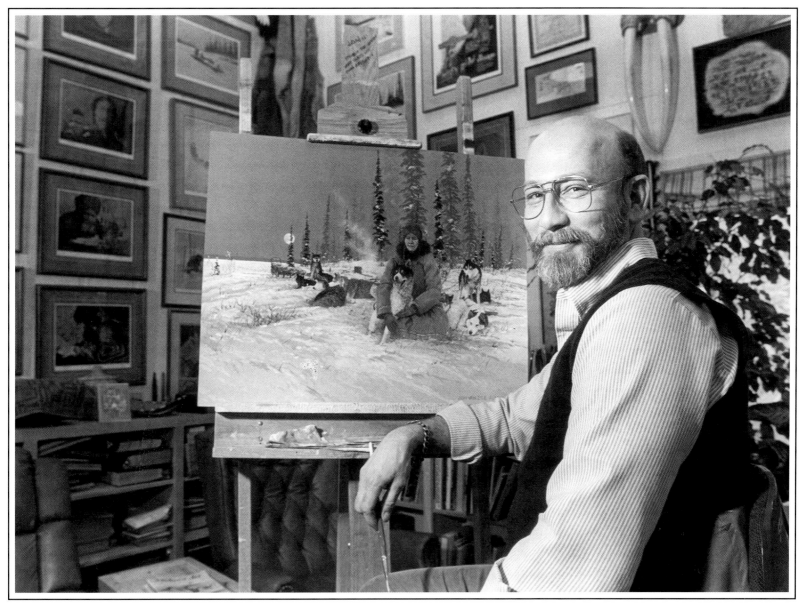

Although Van Zyle is identified with snowy scenes (his best-known works shiver with the look and feel of Alaska winters, achieved by a technique that illuminates his paintings from within), he is a man of many seasons who travels his vast state ranging from the lush rain forests and fishing villages of Southeast to the windy Bering Sea coast, from obscure ghost towns to the splendors of Denali, pursuing the avocations of fishing and hunting and enjoying wildly varied experiences for translation into paintings when he returns home.

Jon Van Zyle relaxes in the sunny studio built by his in-laws.
David Predeger photo

Home is a warm, rustic gallery-studio haven deep in spruce and birch woods at the end of unpaved Mink Creek Drive, about twenty miles north of Anchorage. Here, with his wife, Charlotte, the artist cares for his dogs—now fewer than in his active racing days—and paints. Increasingly fascinated by historical events, he is determined to present authentic interpretations; he "knows" the historic scenes he paints through painstaking research and experience in the country. One finds legendary dog musher Leonhard Seppala observing a contemporary trail scene, and 18th century Danish explorer Vitus Bering overseeing a group of Americans and Siberians meeting in *glasnost*-encouraged cordiality in 1988. Such anachronisms embody Van Zyle's work with a sense of life's continuum and universality.

Much of Van Zyle's art reflects the life, culture and spiritual dimensions of the Native people with whom he feels intense emotional bonds. In many paintings, Alaska friends such as the late Miska Deaphon, revered elder of the Indian village of Nikolai, play major roles. Van Zyle met Deaphon in 1976 when the Athabascan leader was working at the Salmon River checkpoint on the Iditarod Trail, and spent many hours sharing experiences with him during a subsequent month-long visit to Nikolai.

Van Zyle also acknowledges with quiet pride the influence of his wife, who devotes her practical, creative energy to promotion of her husband's work. He counts her two children, now grown, among the immeasureable gifts that have come through her presence and is closely bonded to her parents who built the couple's Mink Creek studio. The artist also cites a deeply satisfying reunion with his father, diplomatically and lovingly orchestrated by Char. The quality added to his life by these relationships may be intangible, but there is little doubt they have profoundly influenced the man and his art.

Bob Pate photo

Above, the artst shares a happy moment at an autograph party with his step-daughter Michelle, who sometimes serves as a model. Below, he shares his interest in muzzle-loading with his step-son, Robert.

Charlotte Van Zyle photo

14

Van Zyle first did originals only, but after he became known and his workload grew heavy, Charlotte established Alaska Limited Editions to publish and distribute his posters. In his paintings, the artist first covers untempered masonite boards with numerous coats of diluted gesso, then goes to acrylics—his main medium. The pellucid effect of his winter scenes—a trademark—is the result of a multi-layered glazing process which intensifies colors and recreates the actual feeling of frost and ice fog.

Each year, Van Zyle's new Iditarod poster is awaited eagerly by collectors. The value of early editions runs to four figures from their modest origins of $5 a copy. Other prints, such as an Alaska series begun in 1983 and countless commemorative editions, have made Van Zyle one of the state's most prolific and popular artists.

His prints are published internationally through Voyageur Art of Minneapolis, Minn., and his posters through Alaska Limited Editions of Eagle River. He has several exhibitions each year in galleries ranging from Fairbanks, Alaska, to Flemington, N.J. His work appears regularly at Seattle's prestigious Frye Art Museum and can be found in collections worldwide.

Official artist of the historic 1988 Friendship Flight from Nome, Alaska, to Provideniya, U.S.S.R., Van Zyle was invited to return to Siberia for an art show, adding hope to a long-time dream of acquiring some sled dogs he can "speak Russian to." He believes it has been about eighty years since the last Siberian Huskies were imported into North America and that acquisition of new stock would inspire enormous response among Siberian dog clubs and owners nationwide, as well as revitalize his own dog yard.

A portrait of the artist reveals a relaxed, gentle man enjoying the rewards of his efforts, his talents and his dreams. Beyond the appeal of the wilderness and its creatures, the sense of history, the expression of all that is moving, magical and mystical about Alaska, one discerns in his paintings intangible brush-strokes that unmistakably outline the shape of happiness.

His attitude of fulfillment, far from being relaxed or replete, is charged with vitality. One cannot imagine a moment when he will feel he's accomplished everything he's imagined and wanted and planned. He seems always on the verge of the next step, that unpredictable "more." For Van Zyle, there will always be so much more. But wherever the trails of his legacy lead him, it is certain that home will always be that house in the woods at the end of the dirt road in Alaska, where past, present and future meet and approve.

The artist spends a quiet moment with Sparky.
Lael Morgan photo

WILDLIFE
...OUR KINDRED SPIRITS

I relate to some of the old Eskimo and Indian beliefs...that all living beings on this earth have a spirit. I'm not talking about a soul. This spirit is related directly to both the animal world and the human world. One should complement the other. Each should support the other. A few of us have been given a visual talent to demonstrate this kindred spirit and to relate to those who accept it.

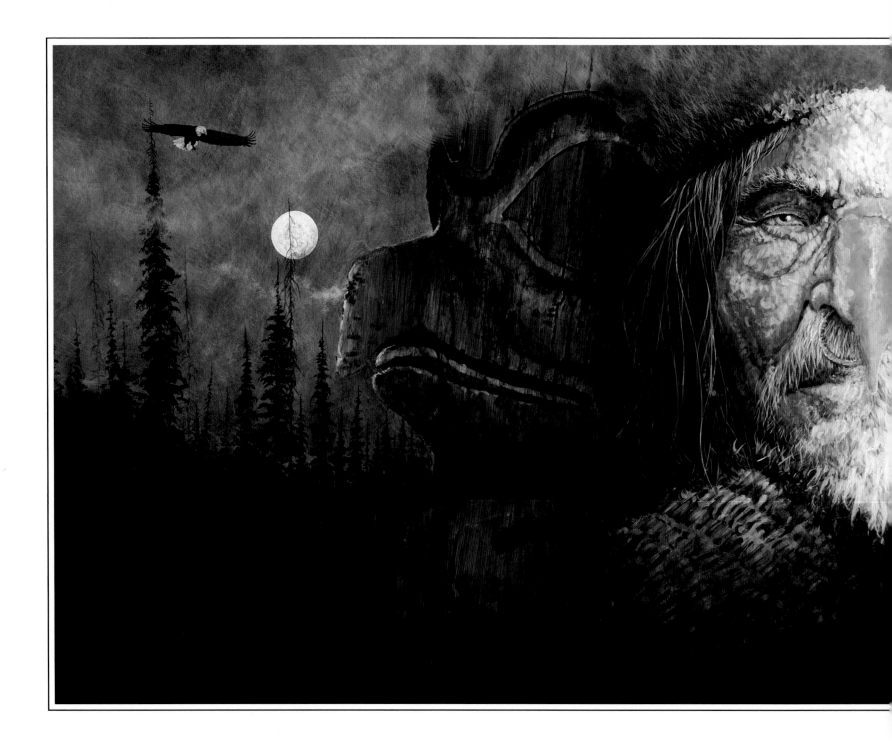

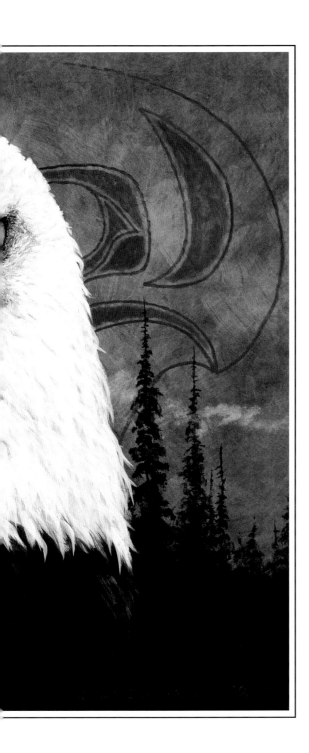

TRINITY

I started this section with the painting "Trinity" to symbolize the relationship between humans and wildlife existing as one on the planet.

In 1988, I judged the Audubon Society's National Exhibit of Alaska Wildlife, and the society asked me to create a painting to become a poster to promote this show. I chose to symbolize unity between the animals and humans, between nature and man, which has great meaning for the Audubon Society. I chose the Indians of Alaska's southeastern region. Their traditional religious beliefs are based strongly on the eagle. They become one. Their totems symbolized their oneness with the animal world. We should all strive toward oneness with nature.

19 x 36 Private Collection, acrylic

19

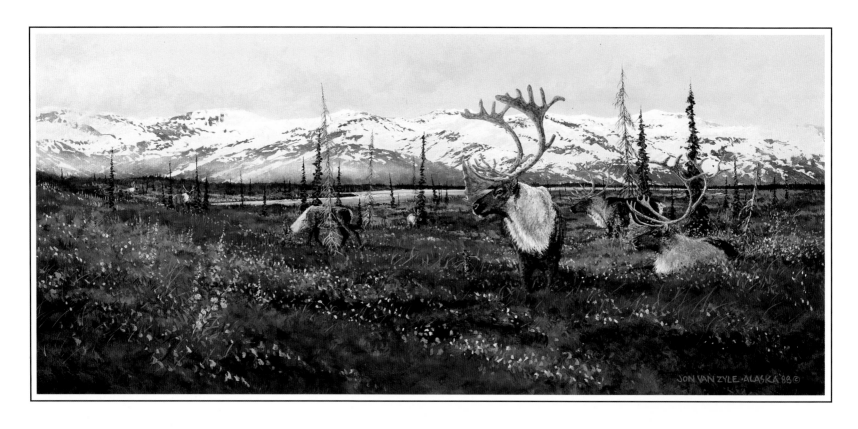

KENAI TUNDRA WATCH

The Kenai lowlands caribou herd was transplanted in 1965 and 1966 from forty-four animals taken from the Nelchina herd near Glennallen, Alaska. The herd has grown to more than one-hundred animals and now ranges throughout the Kenai Peninsula south of Anchorage.

14 x 31½ Private Collection, acrylic

INUA

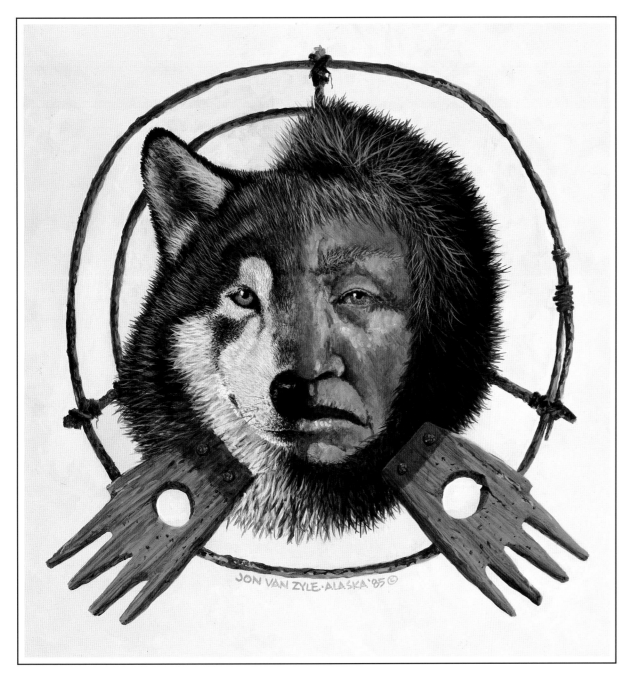

JON VAN ZYLE·ALASKA '85 ©

The Eskimo people of Alaska believe that every living thing has a spirit or "inua." Eskimo shamans of the Bering Sea often carved or had carved the interpretations of these visions. These inua masks were worn on ceremonial occasions and often were destroyed after the ceremony.

I didn't show the actual inua masks but rather the reason behind the mask. This hunter has asked for the power of the wolves' eyesight to enable him to hunt successfully. The man's eyes are slowly turning the color of the wolf's. The holes in the open hands indicate their belief in not taking all the game, but to let some slip through their grasp, to hunt another day. The willow branches are tied around the mask to indicate the circle of life and the people's faces usually were surrounded by a circle...their parka ruffs. While painting this work, I was involved totally and found it difficult to differentiate between the man's features and those of the wolf.

17½ x 18 Private Collection, acrylic

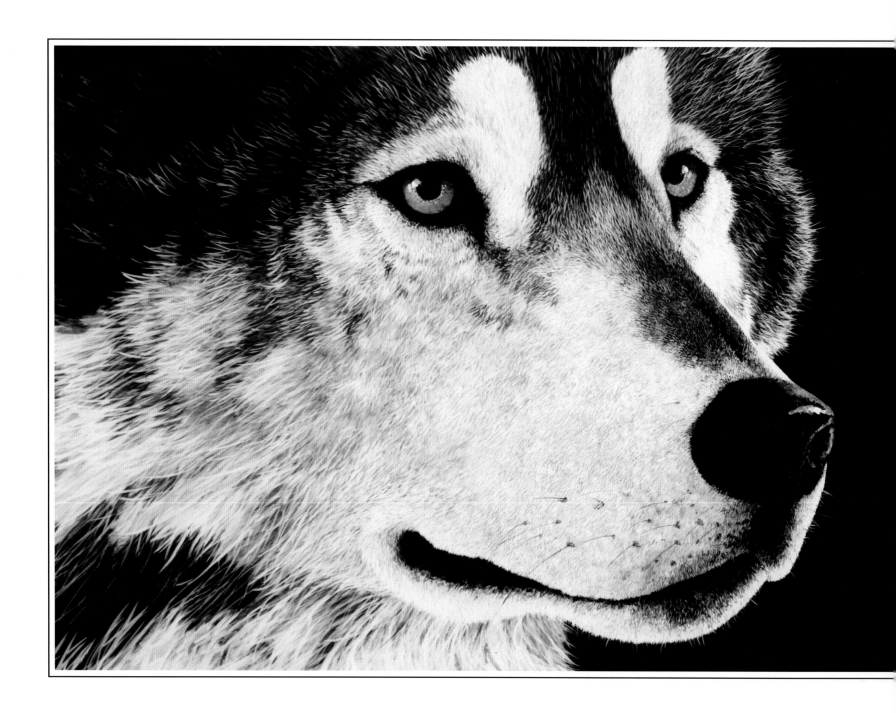

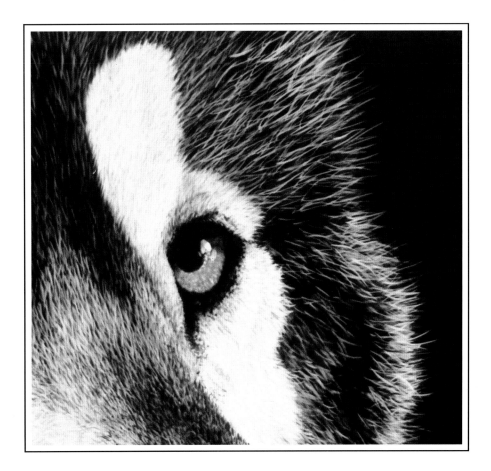

ALL THE BETTER TO
SEE YOU WITH, MY DEAR

While working on this large painting I remembered what my mother had told me many years ago. "Just remember, Jon, that the eyes can tell a lot about a person or an animal." So I started with the eyes. The eyes of a wolf are haunting, and seem to be a part of that mystical thing that they have become.

I love this painting. It started out and finished exactly how I had pictured it in my mind's eye. It told all the stories I wanted to tell. 24 x 48 Private Collection, acrylic

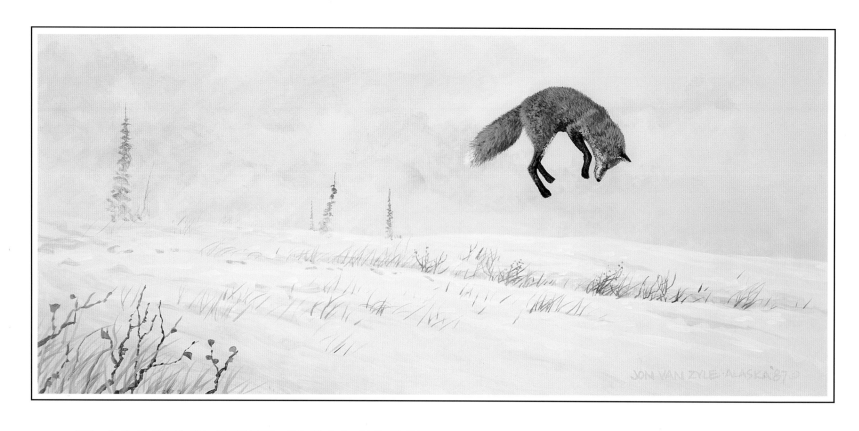

DANCIN' THE FOX HOP

Foxes seem to be almost like cats when it comes to playing with their catches. They will hunt and hunt, then all of a sudden pounce on their catch, sometimes leaping several feet in the air to land on their prey even after the little creature has met his demise.

In planning this painting, initially I wanted to give it a comical title, to accompany the fox's antics. I thought I'd include two foxes...tail to tail, jumping at the same time. I was going to call it "lunch at the golden arches." Nah, too clever!

11 x 24 Private Collection, acrylic

24

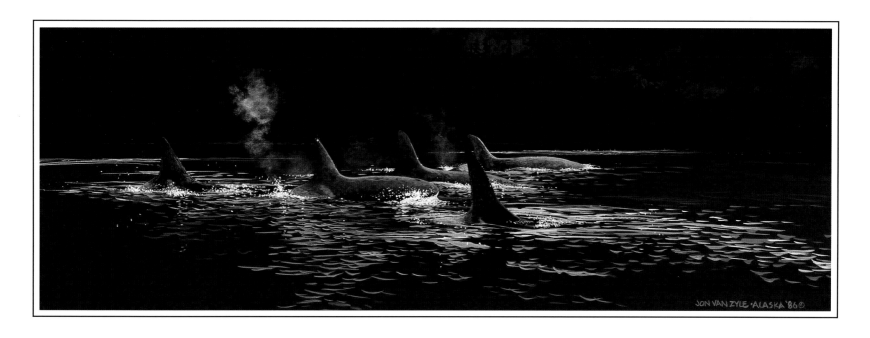

ON THE TRAIL OF THE KILLERS

While on a friend's boat for a week in Prince William Sound, we had the privilege of seeing several killer whales up close. After several hours of surfacing briefly nearby, they finally settled down and seemed to float on the surface.

On the boat I had come up with the title and planned the painting in my head. I must admit that the finished product did not turn out quite as menacing as I had entitled it.

15½ x 44 Private Collection, acrylic

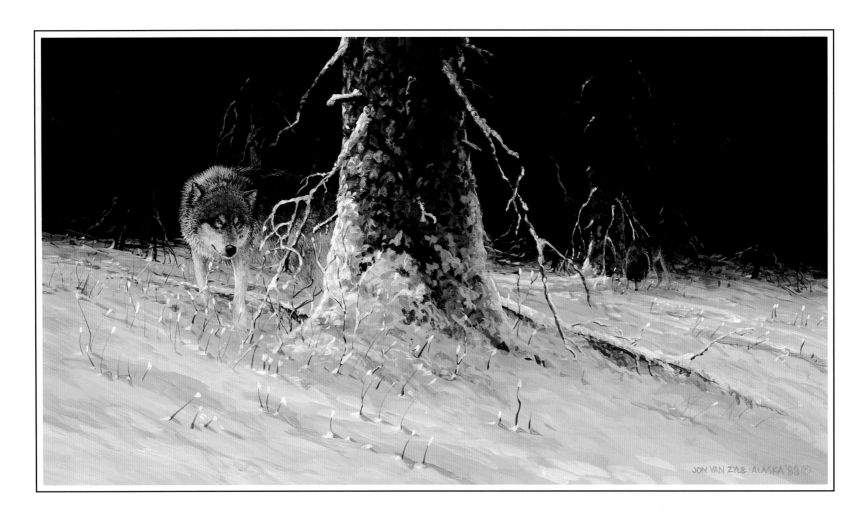

SILENT APPROACH

Unknowingly, during an Iditarod race, I found myself in a position such as this one. I was the one being watched from the edge of the forest.

After I discovered tracks around my camp I vowed to do a painting such as this. The mood I wanted to convey was one of mystery and perhaps even danger. I wanted the viewer to be suspended in a moment of apprehension.

20½ x 36 Private Collection, acrylic

emphasize gold/brown on prelie

SEEKING

In Southeast Alaska, Char and I often take a day off and go fishing. We'll rent a small skiff and troll for salmon or just drift for bottom fish. This day we had been catching a lot of fish and decided to eat lunch. As we drifted past an eagle's perch, we tossed a fish his way, hoping to take some photos if he retrieved it.

Well, it seemed the eagle wasn't hungry or our fare wasn't quite what he wanted. Eventually he did soar down and grab some fish but of course by then not only had we drifted farther away, but had put the cameras away as well.

8 x 33 Private Collection, acrylic

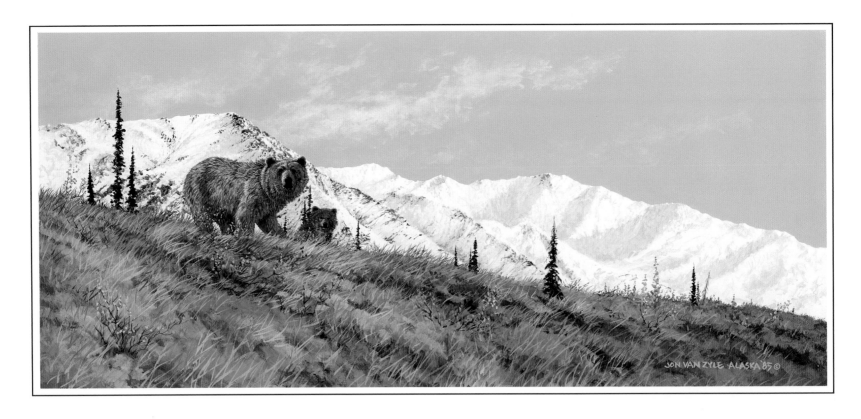

BARELY WINTER

I was asked by the Anchorage Audubon Society to create a painting for the 1986 Alaska Wildlife Exhibition. Char and I had just returned from a trip to Denali and had seen lots of bears. One grizzly had played and eaten his way in front of us for more than an hour.

In this painting, I showed the grandeur of a hillside in Denali Park up against the early snowfall on the mountains. The sow grizzly has just spotted us, and alerts her cub. Bears are an unpredictable lot and, frankly, I would not want to be too close to this mother and her cub. The title of the work tends to take away from the apprehension of being in this spot.

16 x 36 Private Collection, acrylic

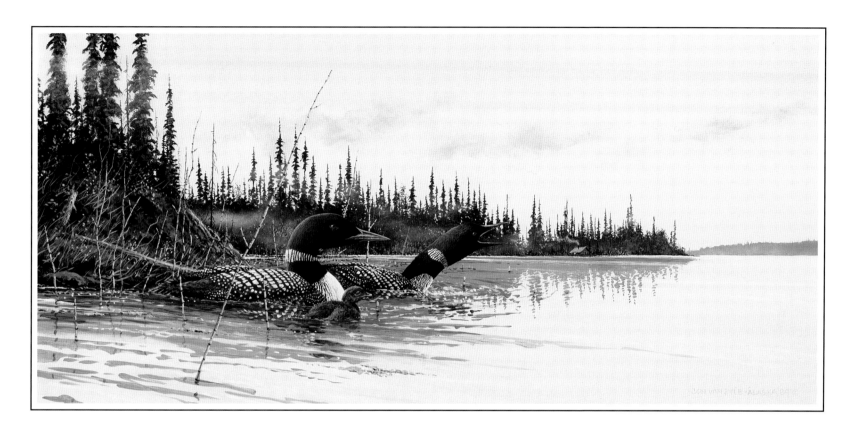

EVENING'S CALL

One of the important things in life is learning to live together in harmony with wildlife. In some of my work I try to emphasize this quietly. Evening's call is such a painting.

The piercing cry of a loon is one of the most haunting, beautiful sounds on earth. These are gorgeously feathered birds whose sleek lines bespeak of speed...that is, until they run atop the water to take off in flight.

In this work, I wanted to place you, the viewer, near this cabin on this early summer's evening...listening to the loons' cries...but from their position in the water.

16½ x 36 Private Collection

FISHING
...A FAVORITE PASTIME

A major part of my free time is spent fishing. I grew up with the notion that unless you caught fish while fishing, it wasn't worth the time. As I got a little older, I realized I didn't have to catch them. Now I can enjoy the moment for what it is rather than for what I might harvest.

I love the sparkle of sunlight on the water and the way the shadows interplay with the sky colors. I would love to be able to master that imagery.

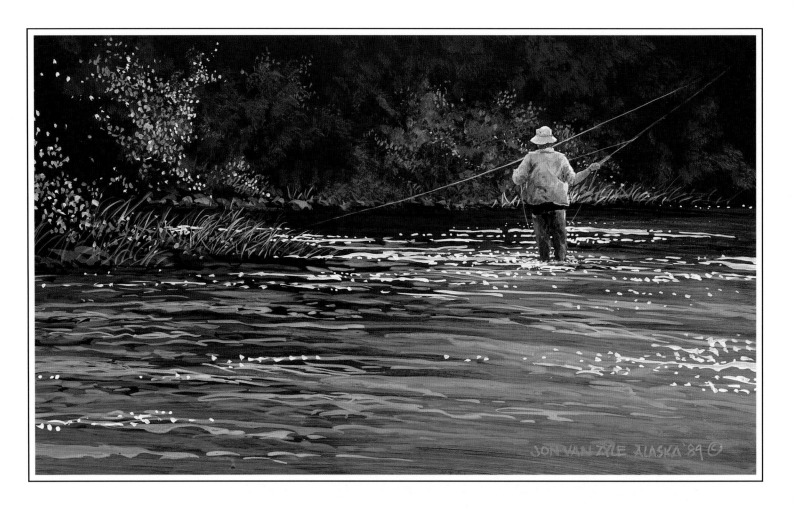

STUDY OF A GOOD FISHERWOMAN

Char and I love to fish...I go about it diligently, while she on the other hand has a relaxed demeanor.

The inspiration for this painting came from a fishing trip. I glanced her way and was struck not only by her casting ability, but also by the beautiful side light that made the entire scene shimmer.

There's something tranquil about a fly line rising off the water, making a long arc, then landing again quietly on the surface. This fisherwoman has been known to catch more fish than I.

11¾ x 40 Private Collection, acrylic

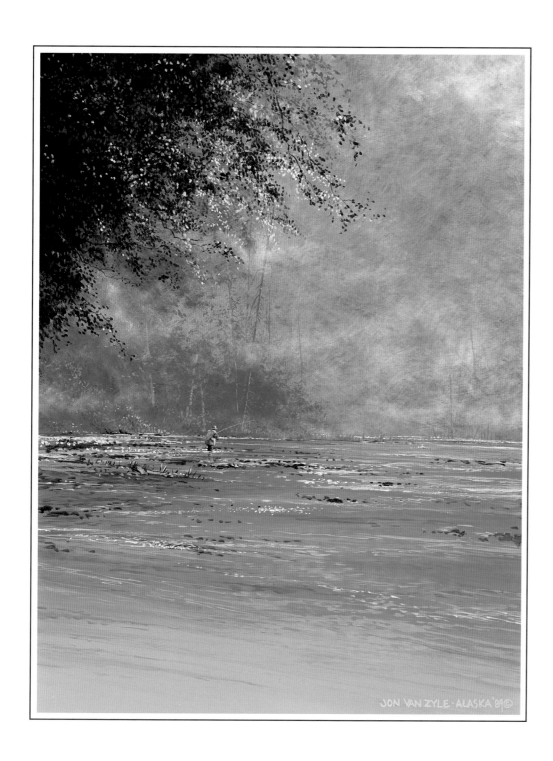

ON THE UPPER KENAI

I've sat on many river banks with the summer sun just barely striking the trees through the mist.

This is one of my favorite paintings... even with the different palette that I chose. I don't normally use the teal greens and blues that I did here. The fisherman's contrasting colors also add a drama to the work. He stands out without being a large subject. It is one of those paintings that came out exactly as I had seen it in my memory.

18 x 24 Private Collection, acrylic

A MORNING MIST

I spent many hours on this painting. I wanted that flat, misty morning mood that comes when the haze or fog obscures all details of the surrounding area. The kind of morning that makes fishing a special event. It's chilly, but you know in four or five minutes, the sun will poke its warm head out and all will be okay.

12 x 48 Private Collection, acrylic

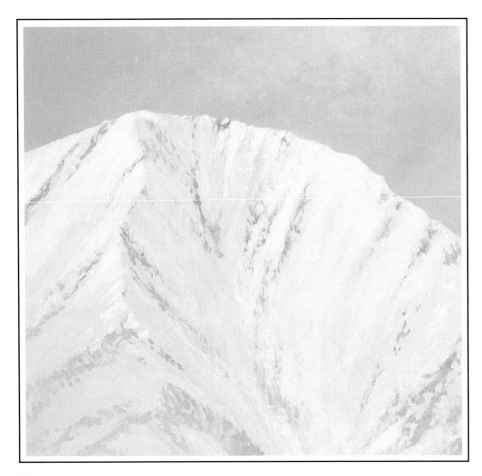

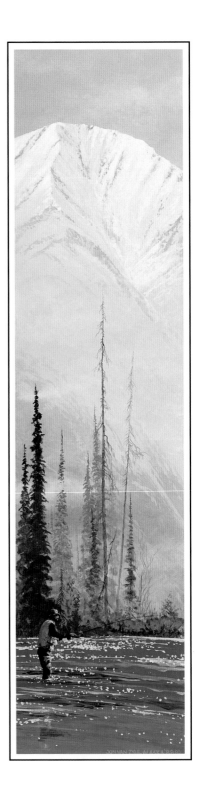

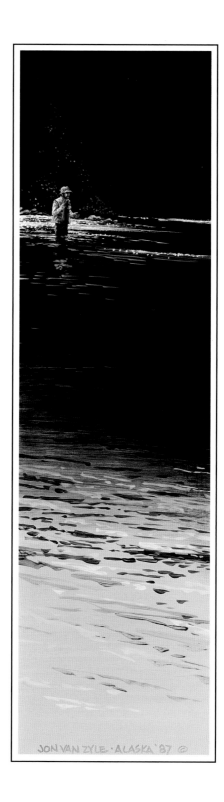

JON VAN ZYLE · ALASKA '87 ©

BELOW THE RIFFLE

In some areas of Alaska, we have a fish called the Grayling. They are a beautiful, large dorsal-finned fish and although they are fairly picky eaters, once they do bite they put up quite a fight. Most Grayling that I've caught tend to be within or just below a riffle of water.

In this painting I was trying to put myself at the end of a riffle of water, just above the pool where all sorts of huge Grayling would be hiding. 8 x 24 Private Collection, acrylic

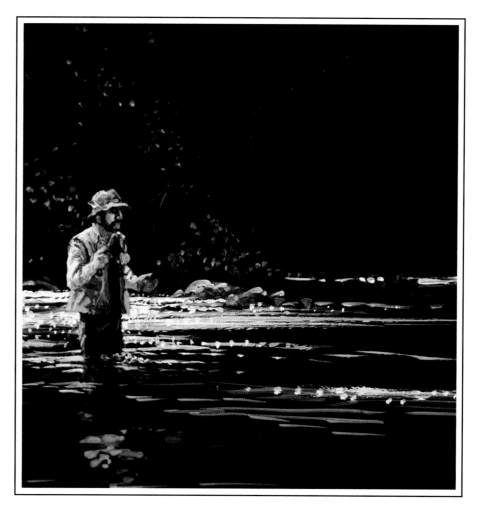

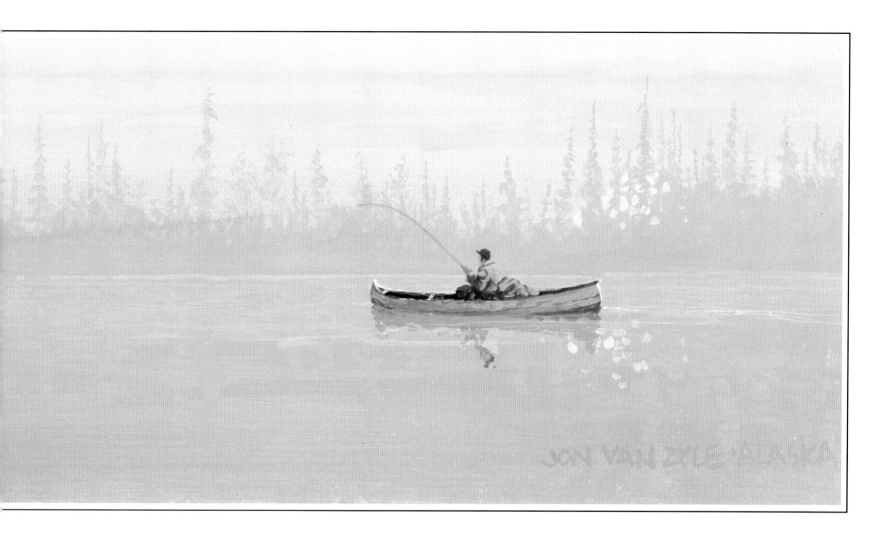

PASTEL EVENING

There are several lakes near our home where Char and I like to fish for land-locked silvers and rainbow trout. One fall several years ago, it was so cold on the lake that ice formed on our line but we didn't mind because the silvers were biting.

The thing I enjoy about this painting is not only those memories but the yellows and pinks and blues in the highlight from the low-angled Alaska autumn sun.

6 x 24 Private Collection, acrylic

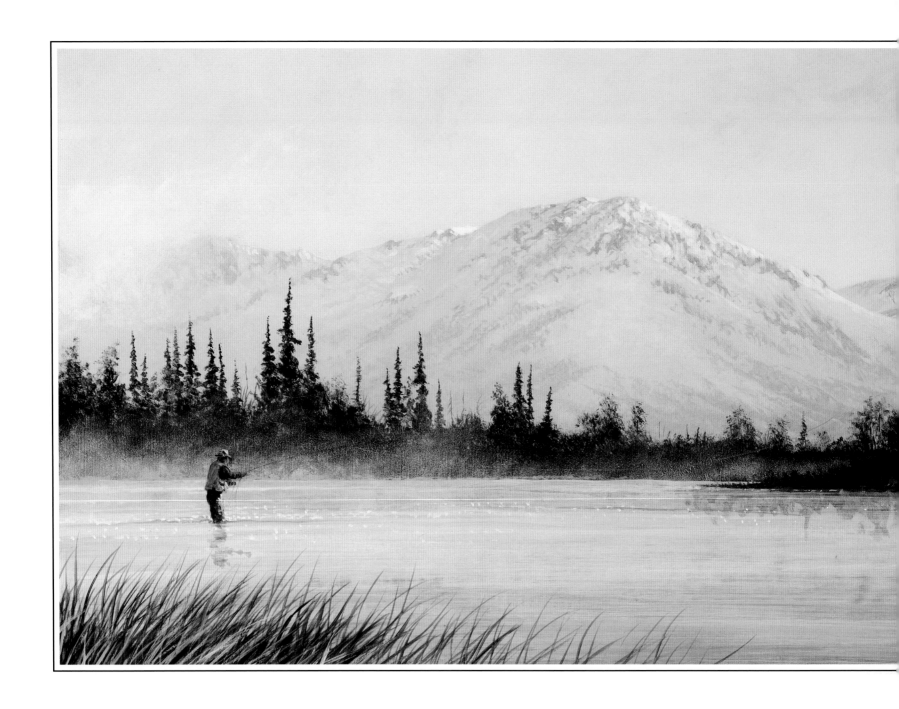

N VAN ZYLE · ALASKA 88©

MORNING CAST

One morning Char and I were fishing on the Kenai. The fog was just lifting from the marshes and grass around camp. There's something invigorating about wading into cold water surrounded by a morning fog. It's almost as if the unseen fish are just waiting to grab the first thing that lands on the water. A little helpful tip: There weren't too many fish at this spot, but if you went around the bend and used a humpy fly...

10 x 20 Private Collection, acrylic

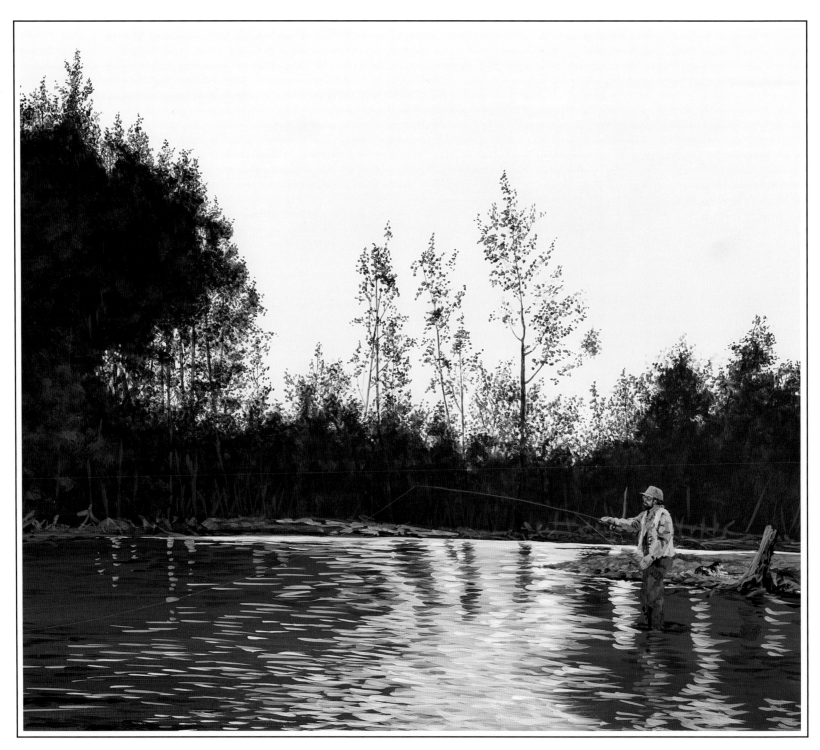

THE LAST CAST

It's the end of a perfect day of fishing. Your dog is faithfully waiting for his dinner. Supper is ready on the stove in the camper and you've almost convinced yourself that it's a little too dark to fish. But you never know. Maybe the big one is waiting...so you'll make just one more "last cast."

20 x 30 Private Collection, acrylic

ALASKA
...THE MYSTIQUE

I always have made it a practice to paint only the things that I've actually experienced or know. But I also like to do historical paintings because of the research we have to conduct and the understanding that it brings to familiar things. I hope I convey the Alaskan mystique in all these works.

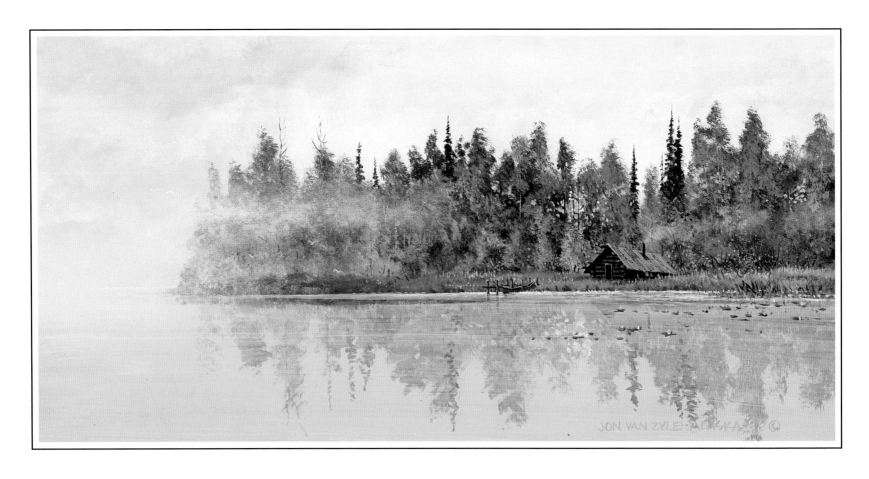

MY FRIEND'S PLACE

When I first came to Alaska, I had a friend whose in-laws had a homestead. Their log cabin was just four logs high, but fairly large, as they had raised several children there. The homestead surrounded a lake where there were zillions of trout. None of the trout were large but they loved being caught. I went moose hunting there once, too. I've spent enjoyable days there with friends. It became one of my favorite spots in Alaska.

This painting is in memory of that place. The painting fades to white in the left-hand corner, much like the memories have faded from my mind. 10 x 20 Private Collection, acrylic

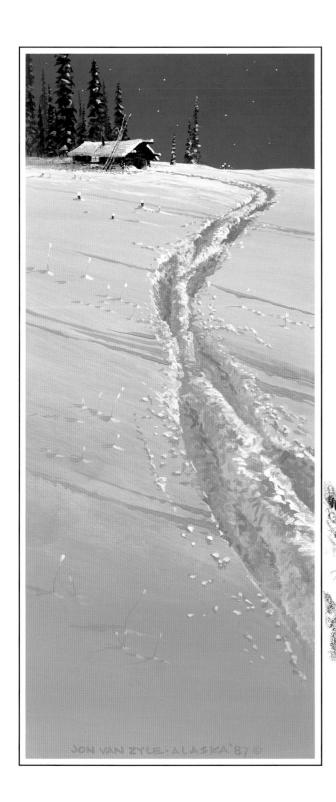

AH, ALASKA!

One of my favorite paintings. It is most everyone's dream to have a small cabin in the woods. The smell of wood smoke, a starry sky, the moonlight reflecting on the night's snow.

The only thing that breaks the spell of this painting is your snowshoe tracks. They are deep as it's the first time you've been to the cabin this winter. Enjoy this place...this moment in your life.

28 x 11¾ Private Collection, acrylic

45

ALASKA ONE

In 1982, Alaska Limited Editions, my poster publisher, took a survey and found few posters that advertised Alaska. As our state was beginning to promote tourism, a decision was made to publish an Alaska poster series.

This first poster was premiered in 1983. It was dedicated to the ideals that made Alaskans stand out as individuals — ideals that still exist today.

The model was my good friend, Darrell Reynolds, who for me personified many of these attributes.

22 x 29 Private Collection, acrylic

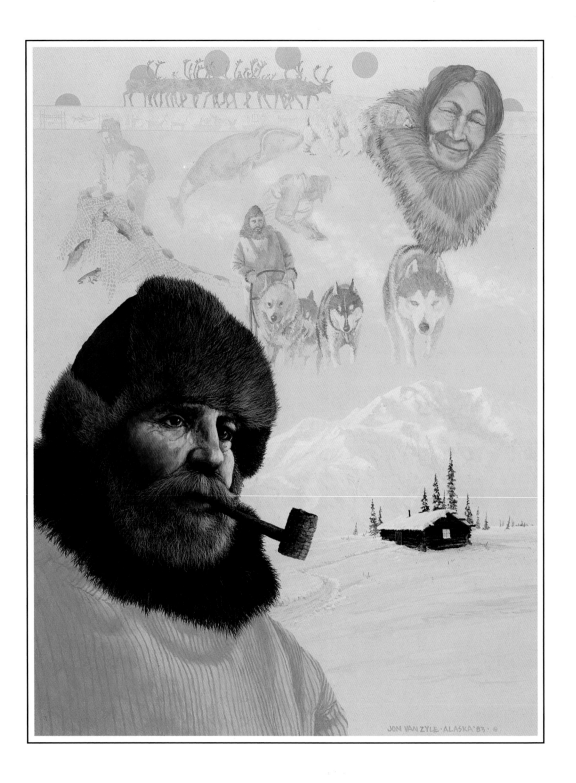

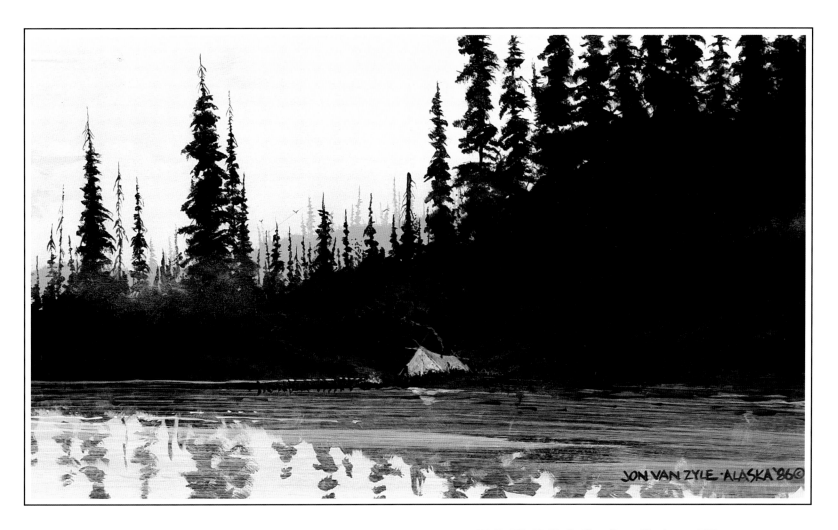

EVENING'S CAMP

Down on the Kenai Peninsula there are a series of canoe lakes that can be reached through portages. On any given summer's evening while canoeing on these lakes you'll come across camps such as this one. The evening light never quite fades, and talk in the camp will continue until three or four in the morning. The smell of the wood smoke from the campfire and light from the lantern will hasten your return to camp in your canoe.

12 x 20 Private Collection, acrylic

WILLOW WOMAN

Char and I stayed in the Indian village of Nikolai at one time. Near our cabin was the trail to the south fork of the Kukokwim River. Twice a day many of the ladies of the village went down to the river to draw their water supply.

Not too far away from us lived the Gregory family. Mrs. Gregory came faithfully each day to draw water. She was such a strong-looking woman, both spiritually and physically, that I had to do this painting of her. I placed her on the path, bucket in hand, emerging from the willows along the river bank. Sometimes the simple village life still calls me.

22 x 28 Private Collection, acrylic

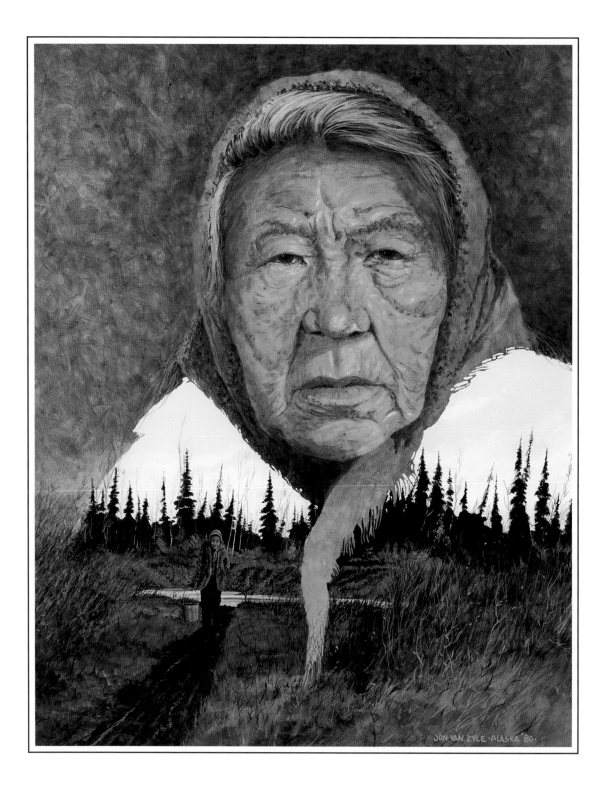

48

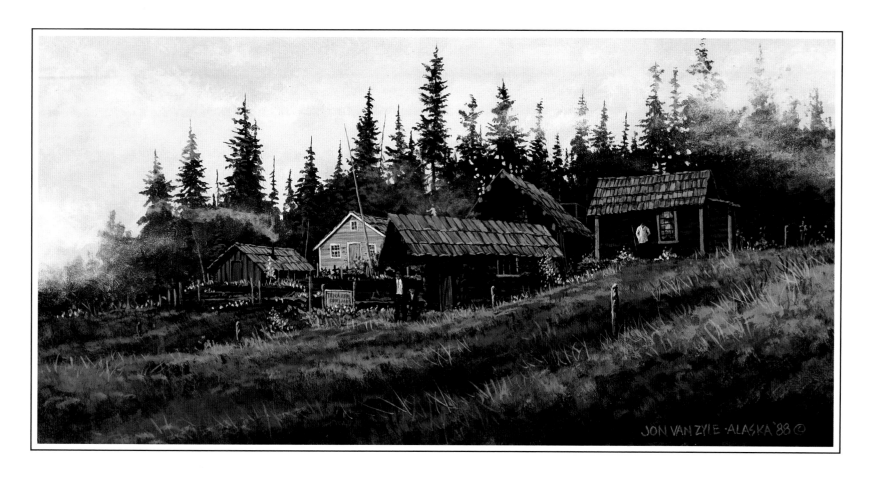

JON VAN ZYLE · ALASKA '88 ©

TENAKEE SPRINGS, CIRCA 1900

The hot mineral water springs of Tenakee were a favorite to the miners who migrated there during the Juneau winters, and even from as far away as the interior of Alaska. Stores and cabins sprung up. And Tenakee is still a favorite of miners and tourists alike.

There are several hot springs in Alaska — near Elim, close to Central and at Sitka to name a few. I wanted to convey the steamy effect as well as the cool greens mixed with a little "blue sky relief" gained by a visit to these warm springs.

10 x 20 Private Collection, acrylic

49

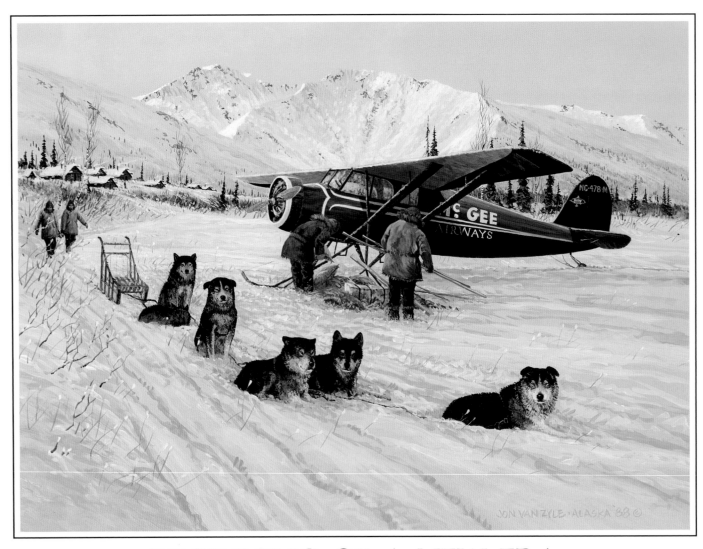

BEGINNING OF A NEW ERA

Dog teams were the king of transportation in Alaska. Around the 1920s, however, the air filled with a new breed of transportation...the airplane.

This painting shows one of the earliest commercial airlines, McGee Airlines, which eventually became Alaska Airlines. Historic paintings such as this are fun, doing the research, learning the relationships between old and new. Airplanes are still the "only" way to get around our vast, mostly roadless state. Flying can be dangerous. Due to the weather and mountains, extreme care must be taken. Char's brother, Roy, nearly met disaster one year when he was severely injured in a small plane crash. He spent months in the hospital. But thanks to Roy's own creed, he is now walking and even has gone back to his commercial fishing.

18 x 24 Private Collection, acrylic

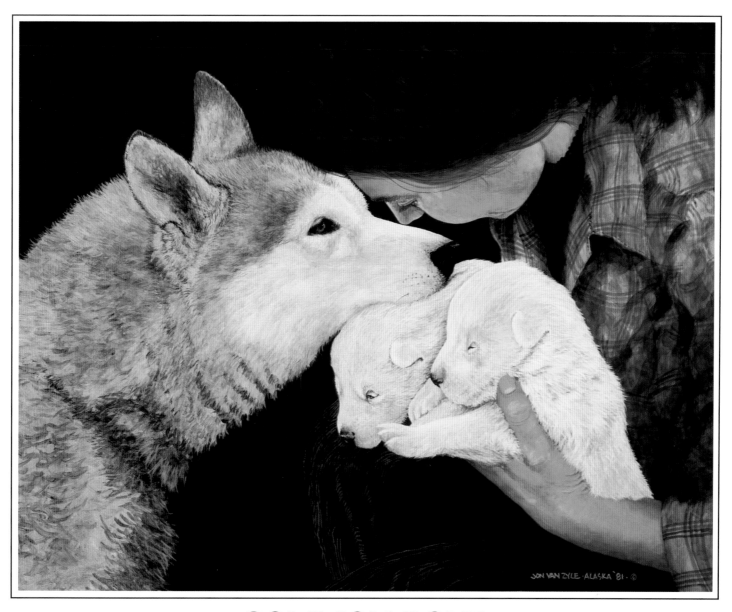

COMMON BOND

This is a painting of my wife and one of my leaders, Belle. It shows a common bond of females of all species, that of motherhood. Char is the mother of two children and Belle also had two pups. Belle allowed Char the privilege of holding her offspring, but still covered them with her muzzle — a sign of dominance and possession.

<div align="right">24 x 30 Private Collection, acrylic</div>

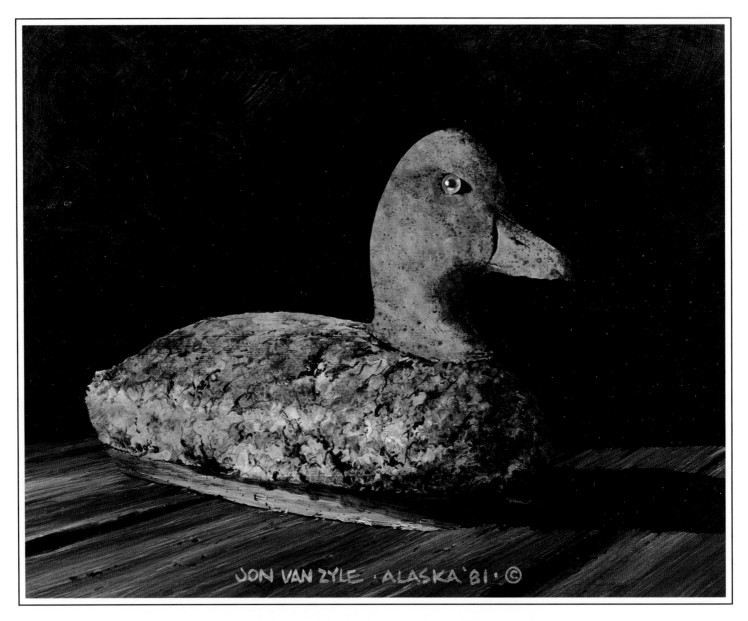

GLASS-EYED DECEIVER

This old decoy once belonged to my mother. After I had completed the painting, a man came to the studio and asked if he could buy it and the decoy as well. It seems the decoy was made by a famous old-time decoy-maker. But some things aren't for sale. 8 x 10 Private Collection, acrylic

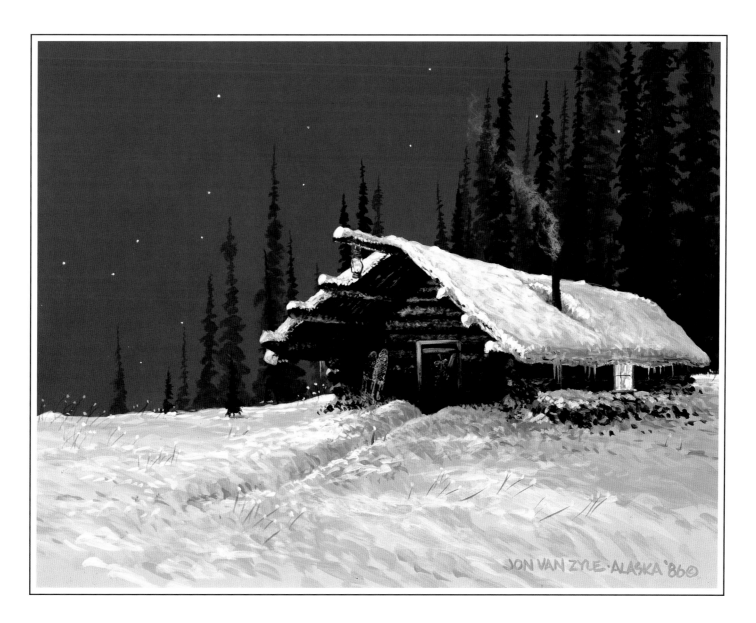

SILENT NIGHT

This was one of two paintings commissioned as a Christmas card. Eventually I painted out the Christmas wreath on the door, but kept the title "Silent Night" as a reminder of the original intent of the work. It has warmth, even on a cold snowy evening.

14 x 18 Private Collection, acrylic

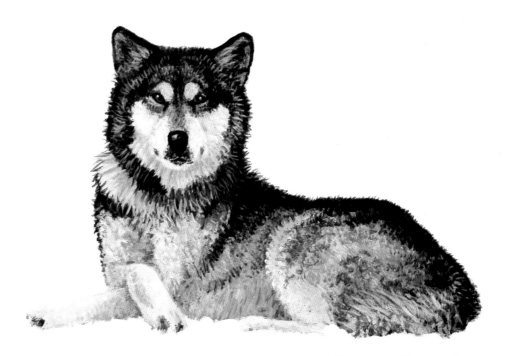

DOGS
...A SPECIAL BOND

From the time I was a little child I loved dogs. After I acquired my first husky, this relationship grew into a special bonding. Huskies are dogs who through the centuries have grown equal to man by the very nature of their work in a harsh environment. Each lives because of the other.

Every one of my dogs has had its own personality. And in the many thousands of miles we've traveled together I've learned from them all.

THE SISTERS

Her name was Pikaki, and she was one of the best leaders I've ever had. She was stoic yet endearing, and her willingness to please was heartwarming. She led me on two Iditarods and over thousands of miles. During her long life I'd wished many times I could have several of her. But I had to settle for just one.

In this painting I've managed to get my wish. I've painted her twice and placed her in a setting where she would be happy — on top of a windy hill, with her sister, mountains, and trees. What a dog! She was one of my best friends, and I miss her companionship.

24 x 36 Private Collection, acrylic

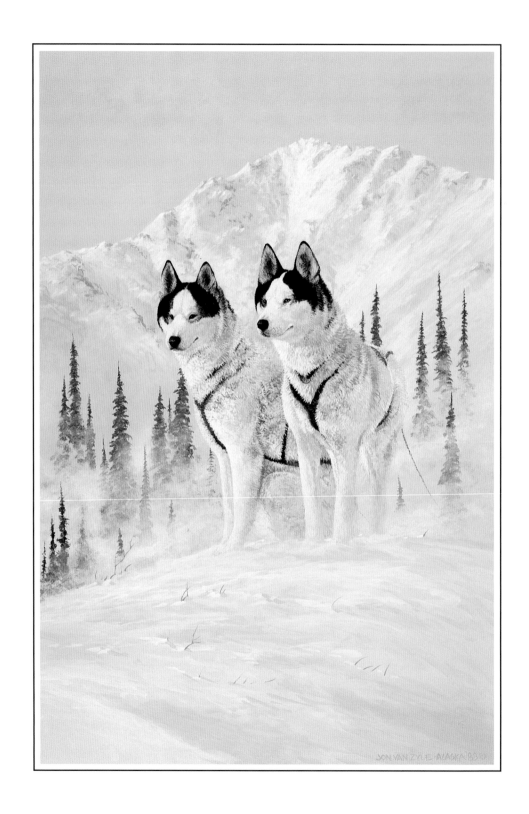

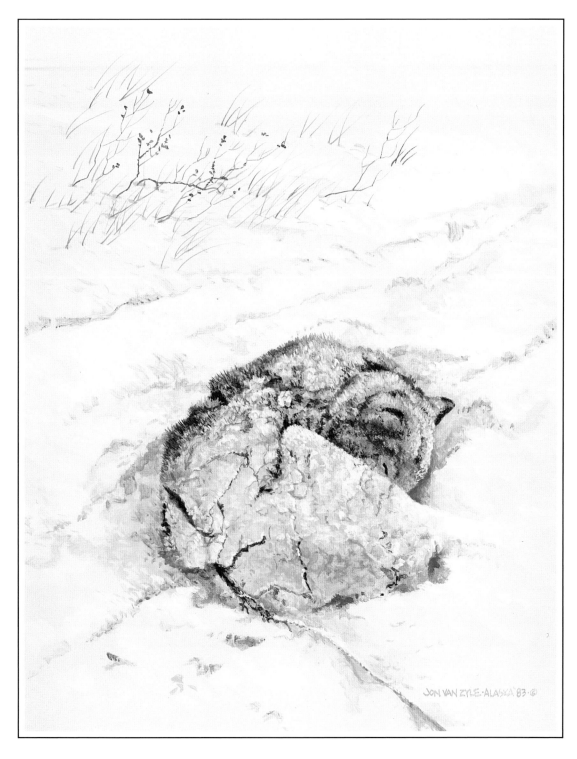

COZY

Her name was Bashful. She was one of the last of an old line of Siberian Huskies. She went to Nome with me in 1976 and 1979, a shy but lovable dog. She was probably one of the most honest dogs I've ever owned.

This painting shows her as she sleeps along the trail after a hard day's work. The winds have been fierce and the entire dog team has become encrusted with snow as it slept. Huskies are so well adapted to their environment that they will simply curl up, put their nose under their tail or leg, and snooze away. Their dense, down-like undercoat protects them from the winds and prevents the snow from penetrating to their skin. She'll sleep nice and cozy 'til I wake her and the other dogs to continue our journey.

14 x 18 Private Collection, acrylic

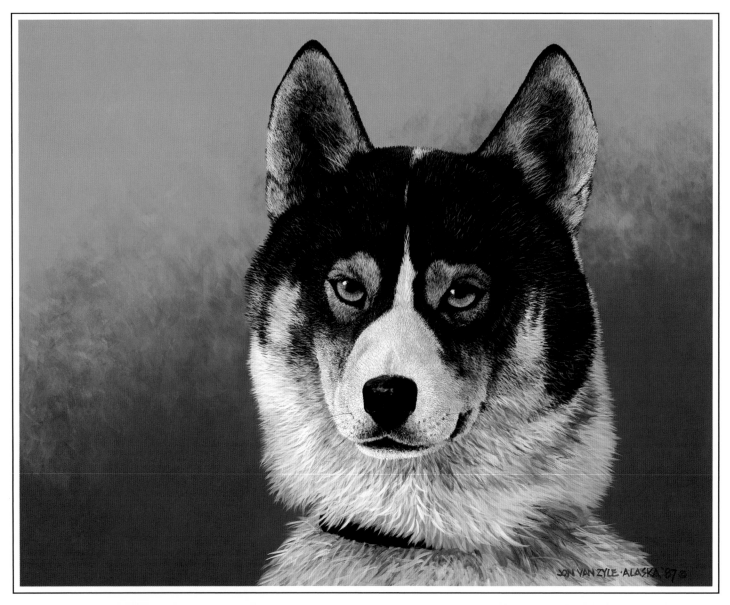

KEKOA WITH THE PRANCING FEET

He was a tough little dog, a son of Pikaki who went with me on my 1979 Iditarod. He shared his mother's qualities, honesty and faithfulness. Kekoa had a special affection for certain people. He loved my cousin Mike, and after Kekoa became lame he went to live with him. They had a special bond and I'm sure Kekoa was happy in retirement.

24 x 30 Private Collection, acrylic

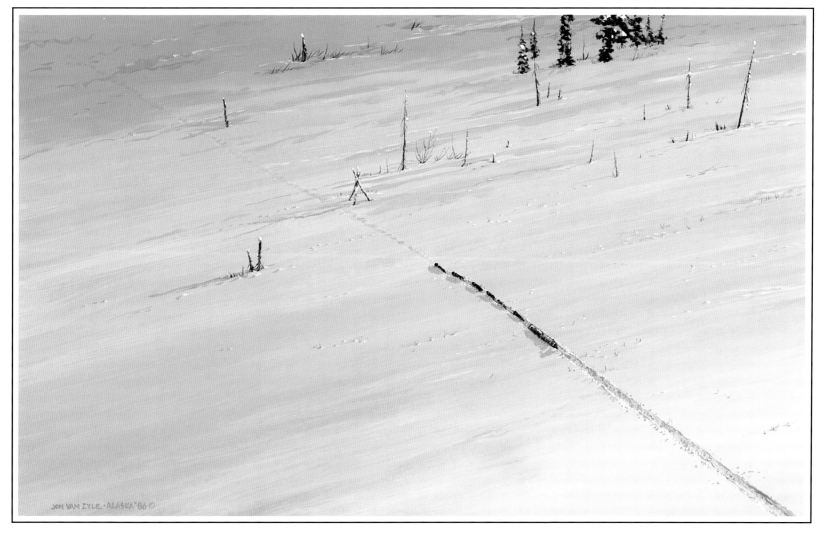

ABOVE THE STRUGGLE

This is one of my favorite paintings, a challenge because of its simplicity. And because I've been there and know this poor guy's seemingly never-ending struggle to get where he's going. You can make out the trail ahead of him. The musher is not riding the runners, but running behind and pushing the sled to help out his dogs. The team is in a tandem hitch, single file with old-fashioned collar harnesses and lines. Soon the musher will rest his dogs by strapping on his snowshoes to break trail himself with the dogs following behind.

30 x 48 Private Collection, acrylic

STALLING

It's early morning and the musher has just risen from a short nap. The dogs have snacked and he is preparing to leave for another day's journey. Somewhere off in the distance there is a strange sound, heard by the musher and a couple of his dogs. The fire feels so good and at thirty degrees below zero just a little comfort is better than none. His leader, like the musher, doesn't want to rouse herself from the warmth of her bed. I've been here, too, not exactly raring to go but knowing we must. Just stalling around until the last glowing ember is gone.

18 x 36 Private Collection, acrylic

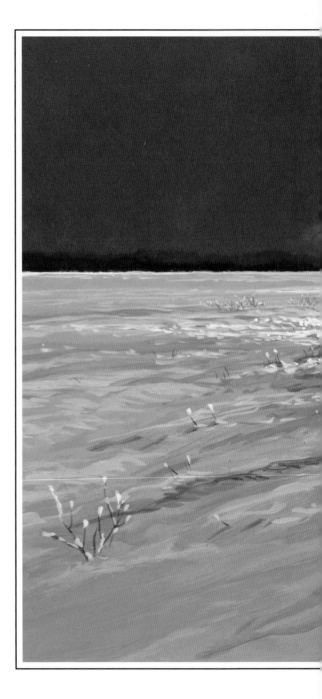

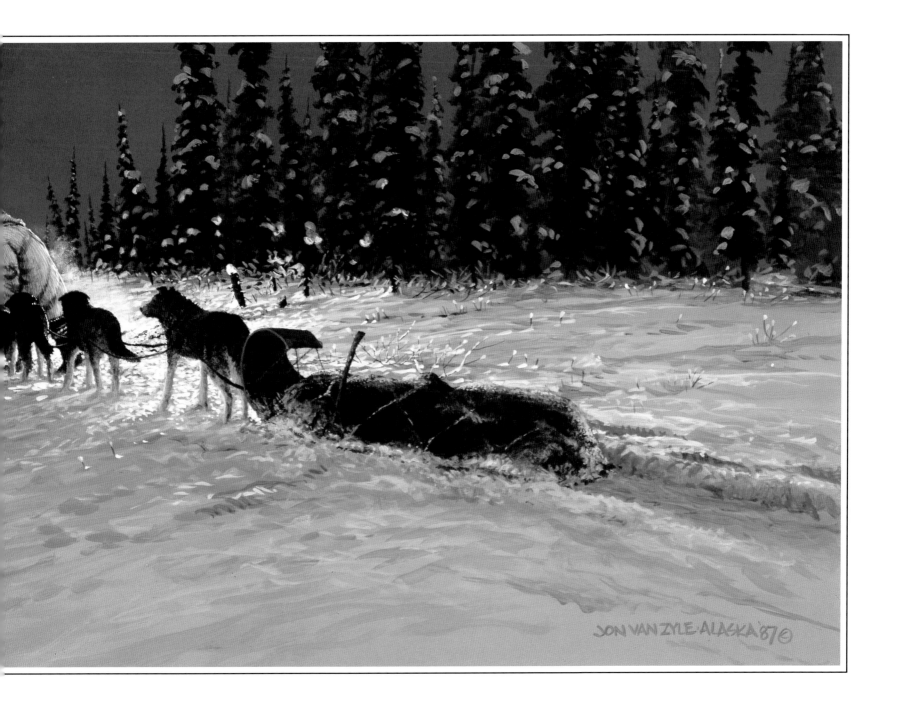

BEYOND THE UNKNOWN
1988 Iditarod Print

On my second Iditarod race in 1979, somewhere between Anvik and Kaltag, the trail runs close to the embankment of the frozen Yukon River. It was a bright, moonlit night. The weather was cold and crisp. The dogs and I had rested a few hours and felt good.

Mysteriously, the sound began as a whisper of voices, barely heard, then slowly grew into the sound of a group of people talking as if at a party. Then laughter started in the background and soon all were laughing — a kind laughter, not menacing. Then someone in the group started clapping. Soon all were applauding and as we got farther down the trail the applause got softer and softer.

It seems I was not the only musher to hear these noises, nor have I been the last. Later, in a telephone conversation, a Yukon River priest promised that if we ever met he would explain the spirits' reasons for their evening visits to a chosen few. I look forward to this explanation and in the meantime will share these wonderful moments with you.

24 x 31¼ Private Collection, acrylic

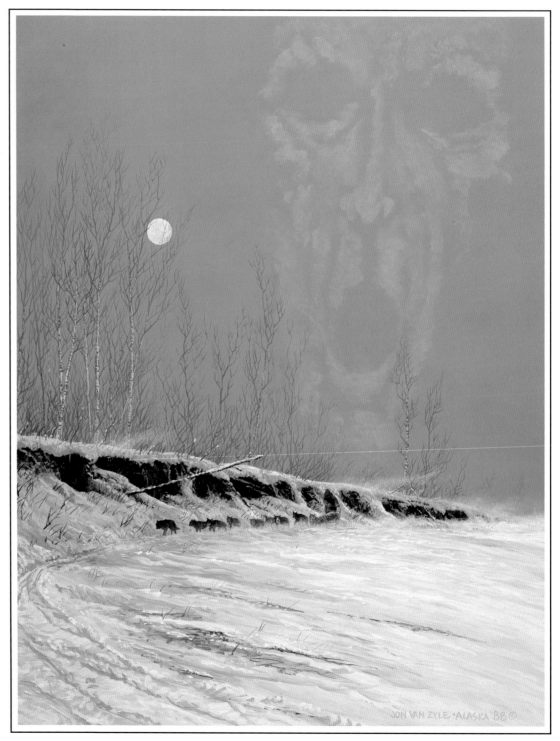

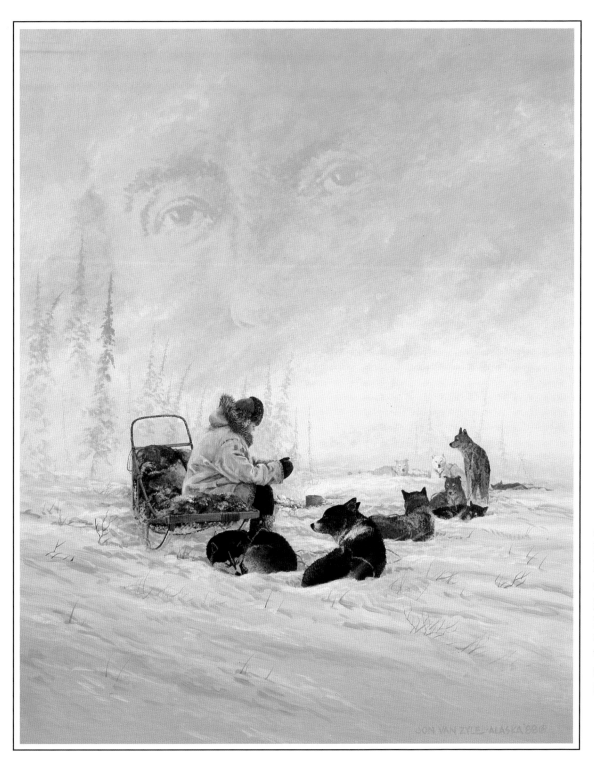

IN DISCOVERY OF SELF
1988 Iditarod Poster

The Iditarod is more than a dog sled race to Nome. It can become a trail of self-discovery. Finding the trail in a windstorm on the coast can be easy compared to finding your own self, your own mind. Hopefully all mushers along this frozen trail will be winners for having searched for, and found, themselves.

22 x 27½ Private Collection, acrylic

THE IDITAROD TRAIL

One of the major networks of trails leading to and from the goldfields in Alaska was the Iditarod Trail. It stretched from Seward to Nome, and from the late 1880s through the mid-1920s, saw thousands of prospectors traveling its course in winter.

In 1925, a portion of this trail was used by volunteers who saved Nome by mushing anti-diphtheria serum to that stricken city.

In 1973, the first annual Iditarod Trail Sled Dog Race was run from Anchorage to Nome, a distance of between 1,100 and 1,200 miles. The trail covers every variety of climate and terrain Alaska has to offer.

There are alternating trails, one south and one north. I've been on both trails, and I much prefer the northern route through Ruby and down the Yukon River to Kaltag. The other trail, from Ophir to Iditarod and then up the Yukon to Kaltag, is slightly longer...and the wind on the river is always at your face.

I ran my first Iditarod in 1976 and my second in 1979. I started producing the annual Iditarod posters in 1977 and have continued to do so every year since then. In 1979, I became the official Iditarod artist.

I've had a lifetime of experiences on these races, experiences that I wouldn't exchange for anything. The people along the trail, the comradery of the mushers, and the closeness and affection we have for our dog teams more than makes up for the discomforts.

Van Zyle is a match for Alaska's rugged lifestyle.
Dennis Corrington photo

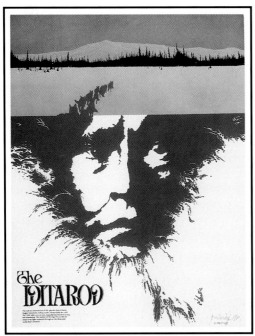

THE IDITAROD

I wanted the face to reflect weariness, to say a lot about the rigors of the race. It's become somewhat of a trademark of the Iditarod. In 1977 we made 2,500 posters and it was going to be a one-time project.
1977 Iditarod Poster

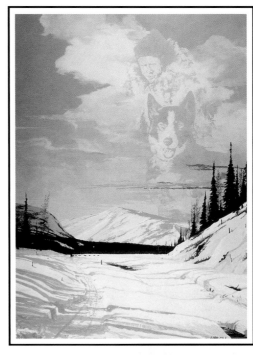

FROM WHENCE COME LEGENDS

Leonhard Seppala, one of the greatest mushers of all time, and his leader Scotty are shown in the sky. Scotty never participated in the serum run but he was one of the best leaders Seppala ever had.
1978 Iditarod Poster

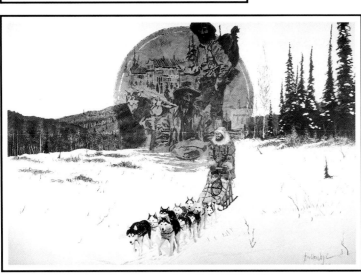

QUIETLY, UNNOTICED, I TOUCHED THE PAST. I AM.

The third one. A statement: We travel through the country, we're part of the past, and it's very much part of the race. You feel this when you go into some of the villages and pass by old mining sites, cabins and roadhouses. We definitely feel a part of the old trail.
1979 Iditarod Poster

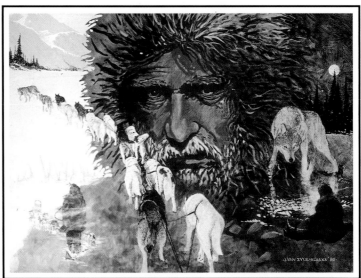

ALONE. TOGETHER. TEAMWORK STRENGTHENED IN SOLITUDE.

I wanted to show some of the pain and hardships that are experienced on the trail. If you show an awful lot of the pain, nobody's going to accept it. So you've got to show it in a "nice way." In every painting where you see dog teams, 90 percent of the dogs are mine. This is my 1979 team. 1980 Iditarod Poster

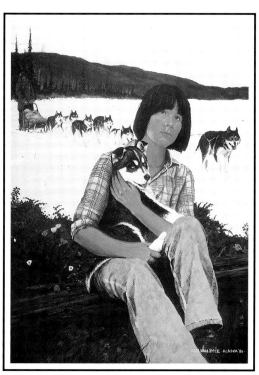

TODAY'S DREAMS, TOMORROW'S TRAIL, YESTERDAY'S MEMORIES

My step-daughter, Michelle, with her puppy, Anchor. I didn't want to show her as a boy, a girl, a Native or a white but simply as a child holding a puppy and thinking about the day that puppy is going to lead the way to Nome.
1981 Iditarod Poster

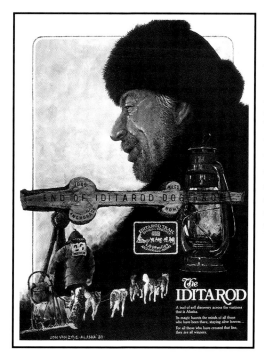

THEY ARE ALL WINNERS

A lot of mushers who go to Nome race to cross the finish line and to claim the prized belt buckle. The person who's last is just as tough and just as determined, and deserves as much credit, as the person who finishes first.
1982 Iditarod Poster

In 1983, I started a new series that consisted of both a "Limited Edition" print and a poster each year.

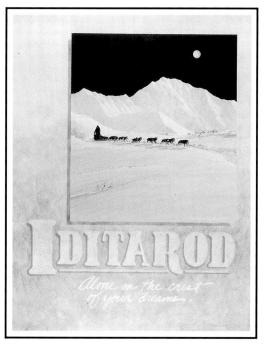

ALONE ON THE CREST OF YOUR DREAMS

"Alone on the Crest of Your Dreams" is up near Rainy Pass, the highest elevation along the Iditarod Trail.
1983 Iditarod Poster

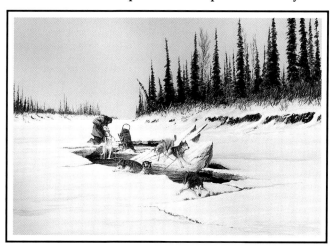

CLOSE CALL

While traveling on a frozen river this unfortunate musher's team has fallen through. Not to worry, though, he'll have them all pulled out and dried off by rolling them in dry snow followed by a brisk run to warm them up.
1983 Iditarod Print

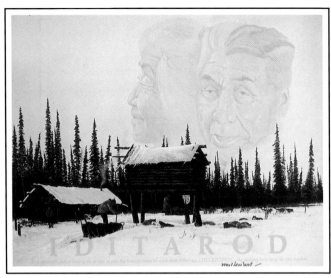

THE CHECKPOINTS

This poster is dedicated to the checkpoints all up and down the trail. It shows the old Salmon River checkpoint, destroyed by fire in the late 1970s. The cabin belonged to a gentleman named Miska Deaphon, a chief in the village of Nikolai. He was a fine old man and a good friend. 1984 Iditarod Poster

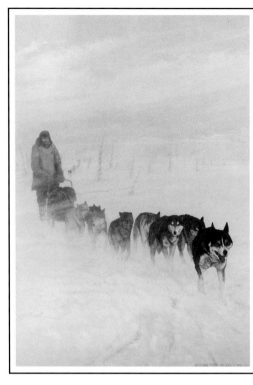

TAKING TURNS

"Taking Turns" expresses the cooperation mushers share when breaking trail for each other, and helping the dogs in their work.
1984 Iditarod Print

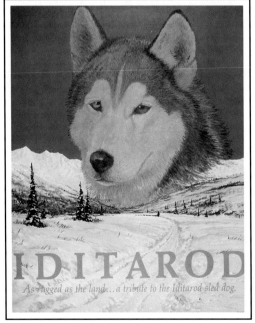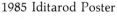

AS RUGGED AS THE LAND

His name was Bobo and he was one of my best friends for many years. He helped take me to Nome in 1976. This poster was dedicated to the true heroes of the Iditarod — the dogs.
1985 Iditarod Poster

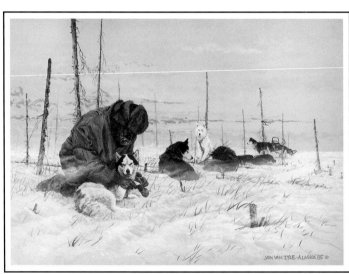

DESERVING THE BEST OF CARE

A musher in the Farewell Burn is putting booties on his leader. You must take care of the dogs 120 percent — and yourself 50 percent. The dogs are more important than you are on the trail. 1985 Iditarod Print

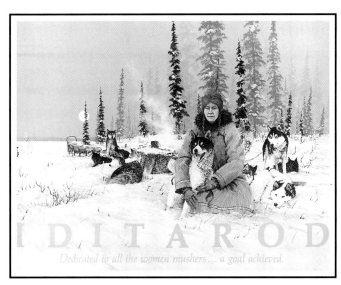

A GOAL ACHIEVED

This is dedicated to all the women mushers who have finished the race. In 1974, the first woman completed the race. In 1985 the first woman won.

1986 Iditarod Poster

THE START OF A LONG FRIENDSHIP

I dedicated this print to my best friend, Dennis Corrington. It shows both of us on the trail where we met in the 1976 Iditarod race.

1986 Iditarod Print

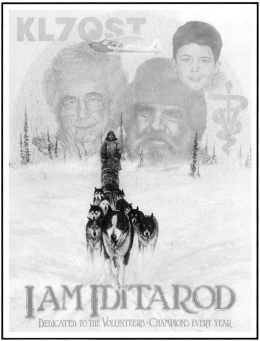

I AM IDITAROD

Dedicated to all the volunteers. Without their help, the race would not be run.

1987 Iditarod Poster

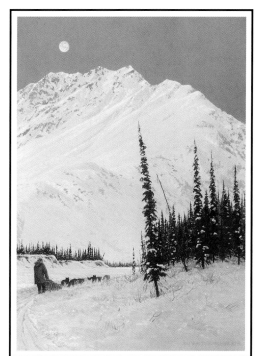

INTO HELL'S GATE

In the 1976 race, we took this trail through the head-waters of the Kuskokwim River. Around this bend we found out why they call it Hell's Gate.

1987 Iditarod Print

STONE LITHOGRAPHY

This art form is drawn by hand on a smooth block of limestone. If many colors are used, then each color must be drawn on a separate stone and properly registered to fit together in the final print. After drawing, the stone is etched with acid and gum arabic. Water is then wiped on the stone and ink is applied, recreating the original drawing. The paper is positioned on the stone and hand-cranked through a press. In a many-colored print, this step is repeated. When the original prints are complete, the stone is ground down so no further impression of that image may be made.

In 1981, I began a series of stone lithographs. These hand-drawn, hand-pulled originals usually are released in editions of one-hundred.

"THOSE WHO ANSWER," 1981

"NIGHT CALLER," 1981

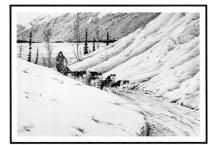
"THE JOURNEY," 1982

"DREAM MAKER," 1982

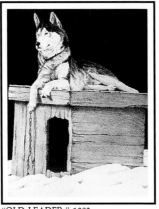
"OLD LEADER," 1983

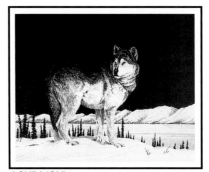
"LONE WOLF," 1984

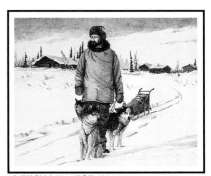
"WHICH WAY TODAY," 1984

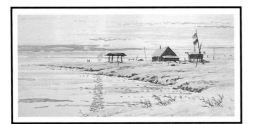
"DAWN OF A NEW DAY," 1984

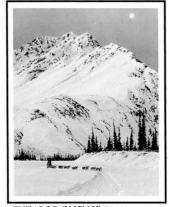
"IDITAROD ESSENCE," 1985

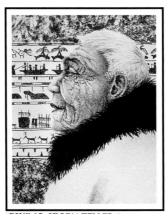
"ESKIMO STORY TELLER," 1985

"ATHABASCAN LEGACY," 1985

72

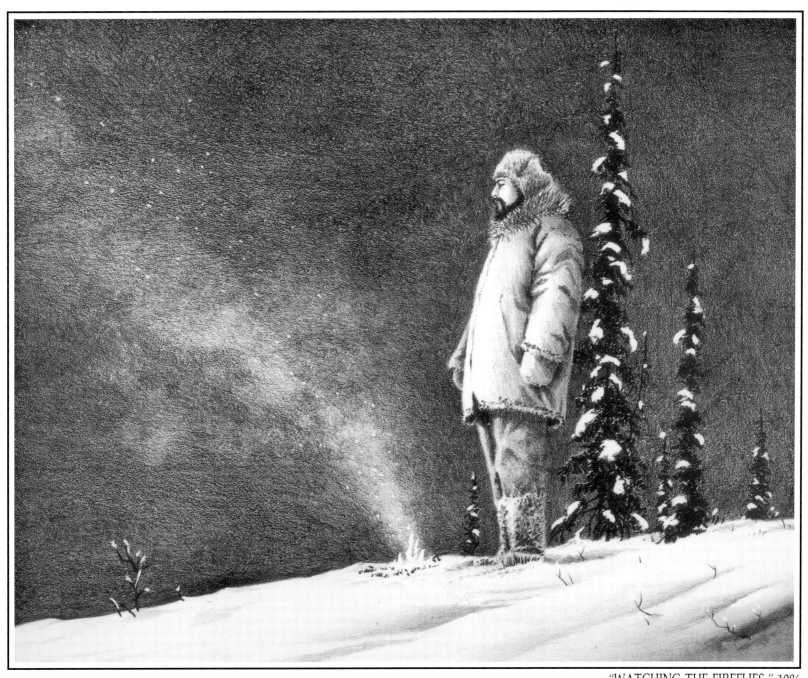

"WATCHING THE FIREFLIES," 1986

73

CACHETS

Through the years, I've been asked to create official first-day-of-issue cachets in conjunction with the U.S. Postal Service, and the Anchorage Philatelic Society. Here are a few of them.

Commemorating Alaska's involvement during World War II: the war in the Aleutian Chain, the building of the Alaska Highway, the establishment of the Alaska Territorial Guard.

Commemorating the 25th anniversary of Alaska Statehood in 1984.

Commemorating the U.S. Postal Service's "dog sled" stamp with first-day ceremonies held in Anchorage.

Commemorating the 200th anniversary of the U.S. Constitution. This was the state of Alaska's contribution to this national event.

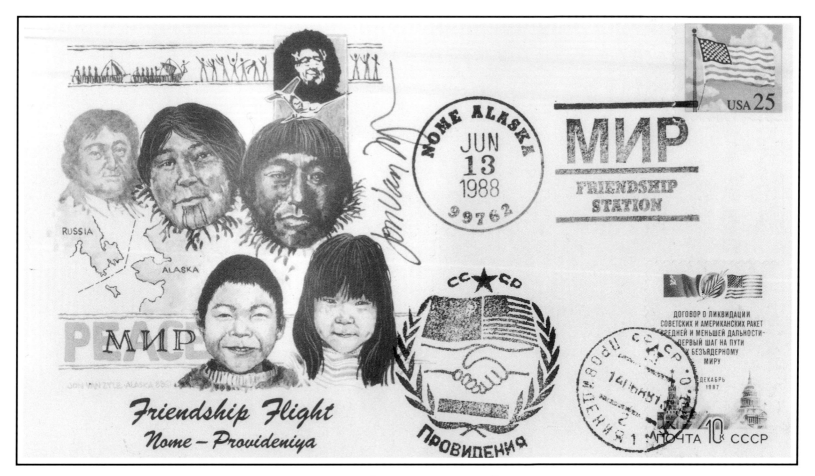

FRIENDSHIP FLIGHT

June of 1988 marked a sincere attempt to establish peace between two nations, and I will remember it forever for my small part.

The Friendship Flight carried eighty-two Alaska Natives, government officials and business leaders. I was asked to go as their official artist. We took off from Nome for the twenty-minute flight to Provideniya, Siberia. The Eskimos of our Bering Sea region once had traveled back and forth between the two nations, and some had relatives on the other side. But this was the first such contact with our Russian/Siberian neighbors since the Iron Curtain came down forty years ago. The meeting of these lost friends and relatives was heartwarming.

I will never forget the people, their kindness, the children, and the welcome given us.

This cachet was designed to commemorate this historic event. Postmarked both in Nome, Alaska, and Provideniya, Siberia, U.S.S.R.

PERSONAL MOMENTS

We had just moved into the studio. The walls were bare. This is one of my favorite photos of Char.
Bob Gault photo

Dan Van Zyle, my twin brother, and I visit our family's homestead in New Jersey.
Charlotte Van Zyle photo

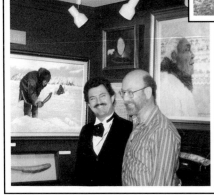

Visiting my old friend, Dennis Corrington, at his ivory museum in Skagway, Alaska.
Charlotte Van Zyle photo

Cousin Mike Harold and I canoeing near our home.
Charlotte Van Zyle photo

One of my dreams come true...meeting and talking with Andrew Wyeth at his home in Chadds Ford, Penn. He's a great artist and a nice man.
Rob Stapleton photo

Another artist-hero of mine, Paul Calle, in his studio.
Charlotte Van Zyle photo

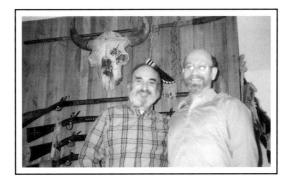

Giving a lecture at the Frye Art Museum in Seattle.
Charlotte Van Zyle photo

Congratulations to Judi Rideout on her award in the Audubon Society's national exhibition of Alaska wildlife that I was honored to judge in 1988.
Rob Stapleton photo

One of my favorite families and favorite galleries, the Grimes clan of Ark II in Flemington, N.J.
Charlotte Van Zyle photo

We entertain many visitors from around the world at my studio...including these Russian visitors from Siberia. Bob Pate photo

...And Japanese from Sapporo.
Charlotte Van Zyle photo

Char and I are at a reception talking with some interesting people.
Bob Pate photo

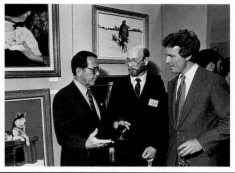

Alaska Senator Ted Stevens and artist Jamie Wyeth at a reception for Alaskan artists in Washington, D.C.
Rob Stapleton photo

At a reception with Char, I'm wearing a traditional Athabascan Indian chief's jacket made of smoked moose hide and fine beadwork.
Rob Stapleton photo

The dean of Alaskan artists, Fred Machetanz. Fred is not only a great artist, he is also a fine gentleman.
Bob Pate photo

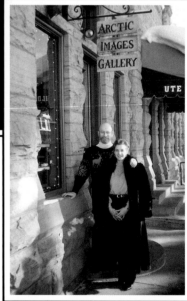

Char and I at The Arctic Images Gallery in Aspen, Colorado.
Bud Hollister photo

GALLERY EXHIBITIONS

Arctic Images — Aspen, Colorado
Ark II — Flemington, New Jersey
Artique Ltd. — Anchorage, Alaska
Black Swan Gallery — Seattle, Washington
First Street Frame and Gallery — Turlock, California
Frames & Things — Soldotna, Alaska
Frontier Frames — Kenai-Soldotna-Homer, Alaska
Gallery of the North — Juneau, Alaska
House of Wood — Fairbanks, Alaska
King Gallery/Sportsman's Edge — New York, New York
Landmarks Gallery — Milwaukee, Wisconsin
New Horizons — Fairbanks, Alaska
Northern Exposure Gallery — Kodiak, Alaska
Scanlon Fine Art — Ketchikan, Alaska
Stonington Gallery — Seattle, Washington
Wildlife of the World — Carmel, California and Aspen, Colorado
Yukon Gallery — Whitehorse, Canada

SELECTED COLLECTIONS

Frye Art Museum — Seattle, Washington
National Forest Service
State of Hawaii
Princess Tours (Princess and Orient Lines)
Anchorage Museum of History and Art — Anchorage, Alaska
Alaska State Museum — Juneau, Alaska
Alaska Natural History Association
State of Alaska, Dept. of Transportation and Dept. of Agriculture
University of Alaska — Fairbanks and Anchorage, Alaska
National Bank of Alaska
Alaska Airlines
Soviet Union Government
William Morris III — Juneau Empire Collection

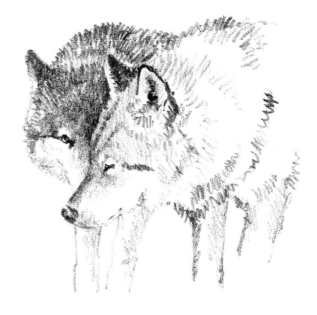